ART OF THE EASTERN WORLD

Géza Fehérvári W G Lambert

R H Pinder-Wilson

Marian Wenzel

Hadji Baba Ancient Art

London

TO RAFFI SOLEIMANI

who initiated me into the mysteries,

his grateful son,

R R Hadji Soleimani

First published 1996 by Hadji Baba Ancient Art
34A Davies Street London W1Y 1LG
Tel No 0171 499 9363
Fax No 0171 493 5504

© Hadji Baba Ancient Art 1996

This book is available in the USA from
Marvin Kagan Inc.
625 Madison Avenue New York
N.Y. 10022
Tel No (212) 535 9000
Fax No (212) 935 7822

A copy of the British Library Cataloguing in Publication Data is available on request

ISBN 0 952062 2 0 8

Designed, scanned & typeset by Digitronix Ltd, Leeds
Printed and bound by Jackson Wilson Ltd, Leeds

CONTENTS

RAFFI SOLEIMANI 1913-1983

I first heard the name 'Raffi' about 30-32 years ago. I was looking for early pieces of Persian pottery in Tehran when a local friend of mine suggested that I pay a visit to Mr Raffi.

I encountered a tall, handsome person with a remarkably open expression. He listened patiently to my request and I still remember his reply: 'Raffi will never sell a fake.'

He proved to be as good as his word and I visited him many times over several years, right up to 1977. He had a sharp eye for objects and was scrupulously honest. Mr Raffi over and above this stood out from amongst the other dealers in Tehran not only for the quality of his pieces, but also for his obviously genuine love for them. I fondly recall the long hours we would spend discussing various objects; unlike so many other dealers, he was knowledgeable and keen to learn more. All the pieces I purchased from him stood up to the scrutiny of experts and museum curators and many are illustrated in Ernst Grube's *Islamic Pottery in the Keir Collection* (Faber and Faber, London, 1976). Looking at these objects, I often think gratefully of the honest dealer in Tehran who would always greet me with a welcoming smile.

Edmund de Unger
Keir Collection
England

One of the most extraordinary persons I have ever come by during my travels around the world was Mr Raffi.

I met him when, one day, I entered his antique shop Hadji Baba in Tehran and it was only after he had made sure that I was an expert on archaeological finds that he allowed me to visit the inner rooms of his shop, which were accessible only to clients such as museums and institutions.

It was in the days when the treasures of Ziwiye and Marlik could be found on the antique market, when we could discuss together these civilisations which had just been discovered and about the importance of Iran as a melting pot of people and art. Raffi was more of an art lover than a merchant. He was an expert on the culture and art of his country and this made him a very sensible and professional dealer. He was able to convey to others his great enthusiasm for art and his love for life. A great deal of the culture and material experience I acquired during my trips to Tehran I owe to Raffi.

The last time I met him was in London. He showed me some Achaemenid objects, but things had to be different this time. Far from his country and from the magical atmosphere of *The Thousand and One Nights* his vision was nevertheless unimpaired and his spirit undiminished. In my mind the legend of Raffi remains intact, like a story of times gone by.

Dr Giancarlo Ligabue
Venice

ハヂババのラフィ氏の想い出

私はハヂババのラフィ氏がまだ店をもたなかった一九六六年から、その長兄のネジァフ・ラビ氏のテヘラン・イスタンブール街角の骨董店に赴き、イランの古代や中世の文物に親しむようになった。私にとってイラン古美術の素晴らしさを教えてくれたいわば恩人が二人いる。その一人がラフィ氏で、もう一人が現在ニューヨークに住むアナヴィアン氏で、この二人は全く性格が違うにもかかわらず互に敬愛し合っていて、同業者として気持ちよくつき合っていた。私はこの二人についてそれぞれの店でペルシアの骨董を手にとってみるのが、十数年にわたった私のテヘラン訪問中の楽しい日課であった。そこえ現れたのがネジァフ・ラビの弟のハヂババのラフィ氏で、彼は新進気鋭の青年骨董商として忽ち頭角を現わし、その店名のハヂババの名はテヘランを訪ねて、ペルシア骨董を集めようという人々の間に拡まった。というのはそれまでの店が山のような骨董品を、ところ狭ましと並べて、まるで倉庫に入ったように陰気であったのに対し、ハヂババの店は広く明るく、商品もよく分類、整理され、美しく陳列されていたばかりでなく、われわれ外国からの客を大いに歓迎してくれ、ガラス柵の品物でも何でも勝手に取り出してみて下さいという、客を信頼した明朗な雰囲気があったからで、店の主人ラフィ氏の快活、豪放な性格が来客を惹きつけたからに相違ない。

今なほ明瞭にテヘラン時代のラフィ氏を想い出させるのは、一九七五年ころ私が日本を代表する小説家の井上靖氏と新進の画家の平山郁夫氏らを連れてテヘランを訪れた時、ラフィ氏の私邸に招かれ、そこで可愛い娘さんの舞踊をみながら、楽しい一夕を過ごしたことである。その後ラフィ一族はイランの宗教革命の影響で、他のユダヤ系の骨董商らとともにロンドンに移り、その店を続けて、ここでもハヂババの店は大成功を収め、その息子のハヂ氏とともにイランを中心とした中近東骨董の店として人気を博した。

私は古代オリエント文化のなかでも最も典雅で、最も親しみやすいペルシア美術との幸運な出遭を回想するごとに、ソレイマニ・ネジァフ氏と、その弟のハヂババのラフィ氏のことを想い出さざるを得ないのである。

一九九三年十月二十三日
ロンドンにて　江上波夫

Translation:

It was in 1966, before Raffi had a shop, that I began to visit his brother Nejat's antiques shop on the corner of the Istanbul road in Tehran and became acquainted with the civilisation of ancient and medieval Iran. There are two people to whom I am undebted for having been taught the wonders of classical Iranian art. One was Raffi, the other is Anavian, who lives at present in New York. Despite their very different characters these two men respected each other and got along well as fellow dealers. It was a pleasurable routine for me during the ten or more years of my stay in Tehran to visit their shops and to hold Persian antiquities in my own hands. It was then that I met Nejat's younger brother, Raffi of Hadji Baba, who appeared on the scene. He soon distinguished himself as an up-and-coming young antiques dealer, and the name Hadji Baba got around among people who came to Tehran in search of Persian antiques. While other shops were cluttered with antiques piled so high that they were as cheerless to enter as a warehouse, Hadji Baba was light and roomy, and the wares were all classified and arranged tidily. Not only that, but visitors from abroad were openly welcome and the atmosphere was one of openness and trust, where customers were encouraged to take items out of the glass cases and examine them. It was without doubt Raffi's cheerful and open-hearted character which endeared his customers to him.

One event which still stands out clearly in my memory of Raffi in his Tehran days is the time in about 1975 when I visited Tehran with the well-known Japanese novelist Inoue Yasushi and the painter Hirayama Ikuo. We were invited to Raffi's private residence, where we spent an enjoyable evening and were entertained by the dancing of his charming daughter. Later, Raffi and his family moved to London along with other Jewish antique dealers as a result of the religious reformation in Iran. He continued trading, and with his son Hadji has seen Hadji Baba flourish. The business enjoys great popularity as an antiques shop specialising in Iran and the Middle East in general.

Whenever I recollect my good fortune in discovering Persian Art, which to me is the most interesting and appealing in the culture of the ancient Middle East, I cannot fail to think of Soleimani Nejat and his brother, Raffi of Hadji Baba.

Namio Egami
Professor Emeritus
The Ancient Orient Museum
Tokyo

1

FOREWORD

It is a privilege to have been invited to introduce this book which R R Hadji Soleimani wishes to dedicate to the memory of his father Raffi Soleimani.

Any foreign visitor to Tehran from the 1940s onwards would, if he had any interest at all in the arts of Iran, at some time or another have visited the Hadji Baba Gallery. This gallery, originally Soleimani Bros., was first in the Avenue Ferdawsi opposite the Turkish Embassy and then in Takht-i Jamshid opposite the Commodore Hotel. Here was a treasure trove of antiquities and works of art offering an irresistible invitation to inspection.

But it was the personality of its owner which made any visit an unforgettable experience. Raffi Soleimani was an antiquary who loved and understood the arts of Iran. With his fine command of English and his infectious enthusiasm, he led many into the way of collecting. Scholars and amateurs alike benefitted from his knowledge and experience.

He was particularly close to the Japanese scholars and collectors for whom he supplied important additions to their collections. A great friend and client was the noted Japanese scholar, Professor Shinji Fukai, of the Institute of Oriental Culture in the University of Tokyo, who from 1956 onwards was a member of the Iraq-Iran Archaeological Expedition of Iran. In his important book *Ceramics of Ancient Persia* (Tokyo, 1981) he acknowledges the support of Raffi Soleimani. Other scholars close to Raffi Soleimani were Professor Namio Egami and Dr Katsumi Tanabe, both with the Ancient Orient Museum, Tokyo.

Foremost among the collectors whom he assisted was Kojiro Ishiguro. His friendship with Raffi began about 1960. Ishiguro has paid tribute to his friend in the introduction to his catalogue, *Ancient Art: Mr and Mrs Kojiro Ishiguro Collection, Volume II Islamic and Related Art* (Tokyo, 1986), where he acknowledges the great and valuable support which Raffi gave to Japanese archaeological studies in the arts of Western Asia. In a Japanese magazine article, Ishiguro has recorded more personal reminiscences when he writes that Raffi was very clever, fluent in English, a stimulating conversationalist, and that he was liked and trusted by all with whom he came into contact.

Raffi contributed greatly to the understanding and appreciation of Iranian art. My own recollections of him are of a kind and helpful friend in whose company there was always pleasure.

In 1979 he came to London to join his son who was already established in Davies Street. He died unexpectedly on 8th January, 1983. He was sixty-nine years old. He is sadly missed by his family and friends. Rabi Raffi Soleimani is a son worthy of his father in whose fine tradition he carries on the family business, Hadji Baba Ancient Art.

The objects described in the following pages were acquired by Raffi or by his son with whom they remain except for a few now in private and public collections.

R H Pinder-Wilson

PREFACE

It has become something of a commonplace that those whose business is with antiquities, whether dealers or collectors, must possess three qualities: a discerning eye, sound knowledge and the wherewithal to put these to good use. Without an eye for pieces of the highest quality, and an understanding in depth of his chosen field, it becomes all too easy for either category of connoisseur to be duped into buying something not really wanted or to be sold a fake.

It has always been my belief that for complete success a fourth, perhaps the most important, quality is needed and that is a profound love for the objects themselves.

My father's house in Tehran was filled with pieces of great beauty and it is thanks to his knowledge, instruction and explanations that I was led to appreciate them from my earliest childhood. I shall never forget the day when I was allowed not merely to look and to listen, but to handle . . . Nor shall I ever forget the occasion when my father said to me, 'When considering these pieces, don't just look at them. Hold them in your hands. Concentrate. Then they will speak to you, tell you about themselves and what they are.' My thirty years in the business of dealing in antiquities have confirmed how right my father was. One of the most important aspects of our business is to distinguish genuine pieces from fakes. It was never easy and nowadays it has become even harder thanks to the ever-increasing ingenuity of forgers and their products. Yet to spot a fake is quintessential. No dealer can afford a mistake, not even one, for word soon gets round and his reputation is lost forever. I believe that my father's teaching and advice, from which stem my own feeling for, and understanding of, antiquities, together with the close relations I have established with experts in my own field and which I have maintained over the years, have enabled me to overcome successfully this perennial problem.

When I joined my father we decided to name our joint business after my father (bābā) and me, using my nickname of long standing, Hadji. This combination had the additional felicity of recalling the picaresque adventurer immortalised by James Morier in *The Adventures of Hajji Baba of Ispahan,* first published in 1824 and now a long-established classic. Morier later wrote the promised sequel telling how 'Hajji Baba accompanied a great ambassador to England . . . of all he saw and all he remarked,' and I like to think that the business my father and I set up relates in many ways to that happy traveller and the good relations he inevitably established during his visit.

Raffi Soleimani with the eminent American scholar, Professor Arthur Upham Pope, in Tehran, 1967

The old Hadji Baba Gallery in Tehran, 1970

HIH Prince Mikasa of Japan with Mr and Mrs Raffi Soleimani, on the occasion of the prince's sixtieth birthday in December 1975 at the Imperial Hotel, Tokyo.

Mr Raffi Soleimani seen between Prof S Fukai and Prof T Kato, the latter the renowned Japanese potter specializing in lustreware, Nagoya, December 1982.

My father's love, his dedication and his example have remained, and will always remain, with me. Without them I would never have acquired that true response to antiquities that derives from love. That is why this catalogue is dedicated to his memory.

I should also like to express my most sincere gratitude to Ralph Pinder-Wilson, not only a highly-respected and renowned scholar in the field of Islamic art, but also a family friend for over thirty years. I wish to take this opportunity to thank him for all his advice during those years and for his foreword to this catalogue. Similarly, I should like to express my warmest thanks to Professor Géza Fehérvári, another old friend and, I might go so far as to say, a member of the family, who has so willingly and so enthusiastically contributed the part of the catalogue devoted to his beloved subject, Islamic pottery. I am likewise grateful to Dr Marian Wenzel for her contribution on pre-Islamic terracotta, the alabaster heads and, of course, the glassware. Dr Wenzels's wide knowledge and her experience are much admired not only by her colleagues and those who know her, but also by anybody who has ever asked her for help in scholarly matters. My thanks are also due to Professor W G Lambert for his descriptions of the early pieces in the catalogue.

I have been fortunate over the years to have had the opportunity to call on the advice and deep knowledge of the late Professor T Mikami, former curator of the Idemitsu Museum, Japan. I am also indebted to the late Professor Shinji Fukai for his friendship and many incisive contributions over the years to the study of Persian art. Also, my sincere thanks go to Dr Sidney M Goldstein, for sharing with me his broad knowledge of ancient glass.

My thanks must also go to my father's old friends, Mr and Mrs Hauge of Virginia, USA, whom the family remembers fondly over many years before leaving Tehran.

Finally, I must express my gratitude to Caroline Haelterman for her work on the catalogue. She drew all the threads together and without her it would have been *un travail de longue haleine* in the most literal sense.

In conclusion, it is my sincere hope that this catalogue will be enjoyed and appreciated by all who share a love for, and interest in, oriental antiquities.

R R Hadji Soleimani

THE SCULPTURAL ARTS OF ANCIENT MESOPOTAMIA, PERSIA AND SOUTH ARABIA

The exceptional assemblage of ancient art from Mesopotamia, Persia and South Arabia, and the outstanding group of pre-Roman and Roman-period glassware which appear in the first part of this volume, serve well the double purpose of the undertaking outlined in the preface: homage to the memory of the well-known and well-loved collector and dealer, Raffi Soleimani, by his son Hadji, and a commemoration of the happy commercial relationship between the Soleimanis and collectors in Japan. In reflecting the discriminating taste of both Raffi and Hadji Soleimani, the group includes some pieces which were bought long ago and sold again by the father and which, after many years in the possession of others, were fortuitously returned to the son.

The pieces which represent the arts of ancient Mesopotamia, Persia, and South Arabia are perhaps more closely in line with the personal taste of Raffi Soleimani than the Roman-period glass. He had the good fortune to be involved with antiquities around the middle of this century when there were emerging from the earth whole new groups of, for instance, early Iranian ceramic art. In fact, three of the pieces illustrated in this section had been cherished by the older Soleimani in his own personal collection, but were eventually released to favoured clients whose collections he was nurturing at the time.

The pieces in this group which were particularly enjoyed by Raffi Soleimani give a lively impression of his taste; he seems to have had a special liking for forms which, to some extent, anticipate the contemporary European sculpture which was most respected during the time he was collecting. For instance, the Early Iron Age zebu-shaped vessel (object no.5) is an example of a prized group which also includes rather more flamboyant versions, some of which have gold earrings. There can be little doubt, however, that this particular specimen is one of the most gracefully formed and one can easily see why Raffi Soleimani loved it; it exhibits the same marked feeling for the fluidity of hollows and mounds, one moving into another, which has characterized some of the best sculpture of our own century.

Similarly, the two magnificent South Arabian alabaster portrait heads with pronounced, columnar necks (object nos.12,13) not only exemplify Raffi Soleimani's own taste, but typify the sort of art from the ancient Near East which was much admired (and often loosely imitated) by various 20th century sculptors. The alabaster heads shown here were most probably votive portraits of local people of some importance, prepared as effigies to be placed in shrines or graveyards, and they were probably originally inserted into at least a token body, or partial body, made of some more perishable material such as wood. They come from an area on both sides of the Red Sea and the Gulf of Aden where for many centuries large and powerful funerary sculptures were designed, as can still be seen in Ethiopia and Madagascar.

These parallels with contempory work apart, there are numerous matters of interest which are raised by the pieces in this group. The alabaster heads are both carved in the style of Qataban, a historical political unit of South Arabia, in what is now part of Yemen, to the west of Hadramawt and to the east of Saba or Sheba; object no.12 is said to have come from the cemetery of Timna, capital of Qataban. Timna was destroyed by forces from Hadramawt in the 1st century AD (Bowen 1958, pp. 199-202), an event which is presumed to have arrested the production of sculpture in the area. Until recently, it was customary to date these alabasters to around the 1st century BC to the 1st century AD, i.e. the period just before the destruction of Timna. In recent literature, and seemingly on the basis of recent excavations, their dating has been moved back to the 3rd and 2nd centuries BC (Caubet 1990, pp. 37-40).

Raffi Soleimani was also obviously intrigued by a kind of informative naturalism which can sometimes be seen in early Iranian art. The steatopygous female terracotta figurine object no.8 and the male figure which is part of object no.10, seem to convey interesting hints about the body ornament and costume worn by Iranian inhabitants in the early first millennium BC. Such north Iranian female figurines, e.g. object nos. 8 and 9, are highly-refined, late variants of an ancient type of Near Eastern figurine, characterized by beak noses, round eyes, and earring perforations. Figurines with these features were produced over and over again (Badre 1980), and their production continued throughout the second millennium BC in the Near East, with versions being made as far west as Cyprus by around 1300 BC.

Constant repetition of the type seems to have brought a rhythmic quality to the design of the later, more highly stylized productions and this is magnificently exemplified

in object no.8. It is remarkable, none the less, to find on the figurine some indications, beyond the ubiquitous earring perforations, of what might have been contemporary local dress. The nudity of the females represented in these figurines need not, of course, be taken as indicative of the usual appearance of Iranian females of the period. A nude female with hands under her breasts is also a standard mode in which sexually powerful goddesses, such as Astarte, Ishtar and the Babylonian Lilith, are represented. Again, these figurines may have been substitutes for wives or courtesans placed in the graves of men to provide future comfort, if they are not images of a protecting goddess. The head-dresses of these figures may represent a widespread fashion at the time, and there is the further possibility that the markings on their generally nude bodies might represent styles of body decoration, either tattooing (which seems to have been practised very early) or the application of something resembling henna.

The male figurine object no.10 depicted on the fragment of a tripodal jar was another favourite of Raffi Soleimani and it is extraordinary in providing valuable, almost unique evidence of an actual style of male dress in Luristan around the 8th century BC. Since there are no wall-paintings or similar sources of information and since even the celebrated Luristan bronze repertoire includes few male figures which are not meant to represent either genii or other hybrids, where authentic local dress cannot be taken for granted, evidence from painted figurines is of great value.

It is possible that the subject of the figurine (opposite, now in the Ishiguro collection) is wearing a kind of ritual male dress favoured in Iron Age Luristan, whilst the figure on the tripodal jar wears another version of Iron Age Luristan costume. The Ishiguro piece belongs to a group of clay figurines from Iran which depict men who are generally phallic and who carry offering-vessels. The earlier versions of these, from the late second and early first millennium BC, were excavated at Marlik, where a female version of the same kind of figurine was also found. These figurines are burnished, and may at one time have been equipped with earrings - their ears are pierced with single holes - but they are nude, and lack any obvious body ornamentation (Negahban 1977, pp. 24, 25, pl. XI). The same sort of phallic vessel-carrying figures were still being

made at the date of the Luristan finds such as the Ishiguro piece, but their bodies were now painted in patterns and the Ishiguro figurine illustrates the sort of adornment shown on this group of vessel-offering figurines.

The Ishiguro piece contrasts most interestingly with the figurine undoubtedly made in much the same locality and at much the same period which is represented on tripodal jar object no. 10. The comparison can be interestingly enlarged by mentioning another painted vessel-offering figurine from Luristan, in the Ashmolean Museum, Oxford (inv. no 1971, 982; Hennessy 1979, pl. 113, anthropomorphic vase, earthenware with painted decoration, Iran, Iron Age, *circa* 8th century BC). The men represented in both the Ishiguro and Ashmolean pieces appear to be dressed in jackets or short tunics and clearly defined boots, the boots of the Ashmolean figure having turned-up toes, like object no.10 here. Their phalluses are, however, unencumbered. The Ashmolean figure seems to display a sort of fringe terminating a sleeved upper garment just below the waist, and the Ishiguro piece seems to have cloth coverings bound to the lower part of the legs, but both figures are certainly uncovered around their loins. The figurine on the tripodal jar, on the other hand, is clearly wearing trousers, so the latter were obviously worn in Luristan in the earlier first millennium BC. The trousers are represented as being of some kind of dotted material as is the belted upper garment, which seems to open down the front of the chest.

One can perhaps hazard that the individuals represented in the two offering-figurines are probably shown in some kind of ritual half-undress, perhaps to do with the offerings they carry; it is unlikely that the genital area was uncovered in the normal dress. It would then follow that the jar-figure is likely to be wearing something which is more like the norm. Interestingly, the boots of the man on the jar, with their definitely turned-up toes, are more explicitly represented versions of those on the two free-standing figurines. A burnished ceramic vessel in the form of an ankle-high boot with turned-up toe, from Iran, Iron Age II, can be found in the Ashmolean Museum (1965.755), and it has been suggested that a boot with a strongly-sewn, turned-up toe would have been fairly general at the time; certainly it protects the foot in stony environments, (cf the traditional leather footwear (*opanci*) still surviving amongst the South Slavs).

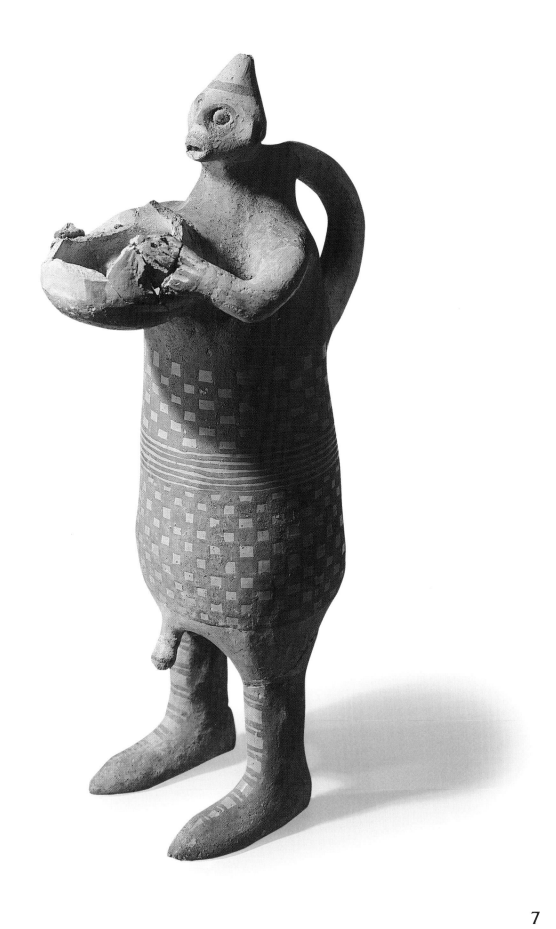

7

1

Sumerian clay tablet

Southern Iraq, Umma
c. 2038 BC
H 17.4cm W 18.9cm

A large highly important multi-columned clay tablet. Inscribed in cuneiform, re-assembled from four main pieces, but with very little damage to the script. The text, which has been translated and assessed by Professor W G Lambert, consists of 229 lines of Sumerian-type cuneiform which are arranged within five columns on each side, with two columns on the reverse which remain blank.

The tablet records the administration of domestic animals in the town of Umma, towards the southern periphery of Iraq, and lists the manner in which the flocks were divided during the course of one year, allotted both as government supplies, and as supplies for the officially supported cults existing in Umma at that time. The particular manner in which animals of one type are distinguished from others within their group gives evidence of the importance of certain features about them. Sheep, for instance, are described as grass-fed or grain-fed, unplucked or plucked.

Religious institutions named in the distribution of oxen, cattle, goats, sheep and lambs include the temple of Shara, and the temples of Enilagarsikilla and Emakhsikilla. Statues also receive mention; animals were sacrificed to them, while other offerings were made on public occasions, such as Eshesh festivals, and the cold water ceremony. The names of ceremonies can serve to describe their nature, such as that of the offering to the Lyre, on the day of the moon's disappearance. Animals are conducted to their destinations by cupbearers, officials, and a physician.

This is the most important tablet preserved of its type, presenting a highly comprehensive view of that most valuable aspect of Sumerian civilization, the administration of domestic animals. The nearest tablet approaching this specimen in quality is that which is preserved in the Yale Babylonian Collection (YBT IV 207), which is, however, shorter, and much less perfectly preserved.

The tablet relates to Amar-Sin, third king of the Third Dynasty of Ur, in the 9th year of his reign, around 2038 BC.

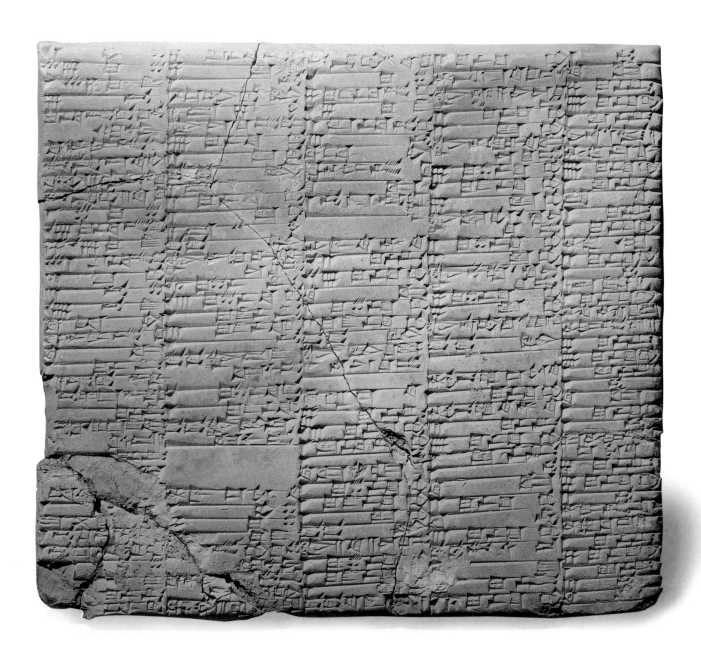

2

Akkadian cylinder seal

Central Mesopotamia
c. 2300 - 2200 BC
H 31mm D 19mm

Cylinder seal, black serpentine. Two quite separate parts constitute the design: three figures wearing only short kilts are walking to the left. The first two both carry a heavy stoppered jar on their backs, secured by cords over their shoulders and grasped in their left hands while another cord is passed round their foreheads. The second figure also carries a smaller container, apparently a Sin bottle secured by cords hung over the right arm. The first figure's right arm is in the same position but carries no bottle. The third figure, whose hair is clearly held in place by a band around the head, carries an axe over one shoulder.

The second part shows a hunting scene consisting of three mountains, two trees and two bushes, six wild quadrupeds, a bird, a porcupine (?), and two hunters in short kilts carrying large quivers decorated with foxes' tails (?) who aim their bows at their quarry and are accompanied by two hounds.

The three figures in the first part are two porters with loads escorted by an armed guard. Whether the juxtaposition of the hunting scene implies that the porters are going through terrain remote from civilization is a question to which there is as yet no answer.

This is a masterpiece of Akkadian seal engraving and shows the degree to which the artistic freedom brought about by the new style of government under the kings of Akkad resulted in much innovation and great achievement. This seems to be the only seal showing porters travelling with an escort. Only a very few seals with similar hunting scenes are known and none matches this example.

Comparative material
R M Boehmer, Die Entwicklung der Glyptick während der Akkad-Zeit, Berlin, 1965, figs. 718a-723.

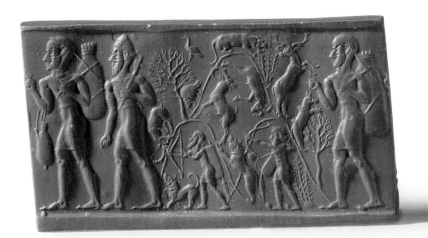

3

Kassite dog's head

Iraq, Isin-Larsa
19th century BC
H 12cm W 17cm

Sculpted head of a mastiff-like dog, pale tan baked clay. The clay is highly desiccated and crystallized in places, and bears traces of red pigment in the incisions of its design. The head is rendered with considerable naturalism; the animal is shown with an open mouth and well-formed teeth; the back of the gullet is carefully smoothed and there are holes indicating whiskers. The ears are rather irregularly placed, giving the face a somewhat quizzical expression. Wrinkles over the eyes are indicated by a rhythmic arrangement of curving and looped incisions and there is a pleasing complexity of concave and convex areas. A concave area represents the curvature of fur under the chin. Beneath is represented a roped cord which joins another running down the middle of the animal's neck at a point where there was perhaps once a knot. The neck has obviously been broken away from a larger sculpture. There is a teardrop-shaped hollow in the top of the head, some 2.5cm deep, presumably for the insertion of something now lost.

This piece belongs to a rare group of fragments of highly naturalistic sculptures of collared dogs in pale clay which have come to light in southern Mesopotamia. A certain number was excavated by Berthel Hrouda in the precinct of a temple of the goddess Gula to whom dogs were apparently sacred. The sculpture is best dated to the 19th century BC, the period of the carved and inscribed steatite figurine of a mastiff found at Tello (Louvre AO 4349), to which it bears a striking resemblance.

Comparative material
Frankfort 1970, p. 56, fig. 34; Hrouda 1977, pl. 9; Hrouda 1981, p. 66, pls. 25, 27; Muscarella 1989, pp. 115-16, cat. no. 71; also Ishiguro 1976, pl. 34, where the head of a figurine of this group is certainly misattributed to the later Kassite period, 14-13th century BC.

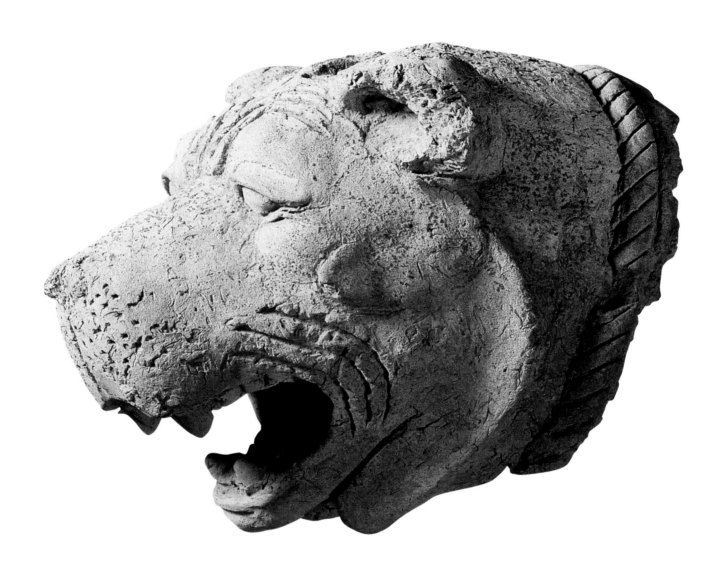

4

Luristan clay figurine

Iran, Luristan
1000 - 700 BC
H 32cm

Baked clay vessel of a man holding a fragmentary jar, with garments indicated by elaborate painted ornamentation in wine-red. The vessel has a handle at the rear, and aperture at the back of the neck allowing it to be filled with liquid, which emerged from the mouth.

The individual depicted has a small head upon which is a pointed cap. The eyes are incised rings flanking a minimal nose over protruding lips. The feet are proportionally large, and are encased in dark boots finishing around the knees, which have horizontal, double-band lacing. The bulky, tubular body is dressed in a high-necked tunic which terminates above the groin (see Introduction). The top of the garment is solid in tone, but from the chest down bears a chequer-board motif, broken only around the waist by a cluster of parallel and horizontal bands indicating the sort of wide belt popular at the time, as found in Iran associated with archaeological material from the earlier first millennium BC.

The chequer-board design of the garment can be seen on ceramics from Tepe Sialk, near Kashan in Central Iran, dating to the early centuries of the first millennium BC (Kawani 1991, pp. 25, 26, fig. 30).

Mr & Mrs Ishiguro collection

Comparative material
Comparative material is given in the Introduction, pp. 6,7.

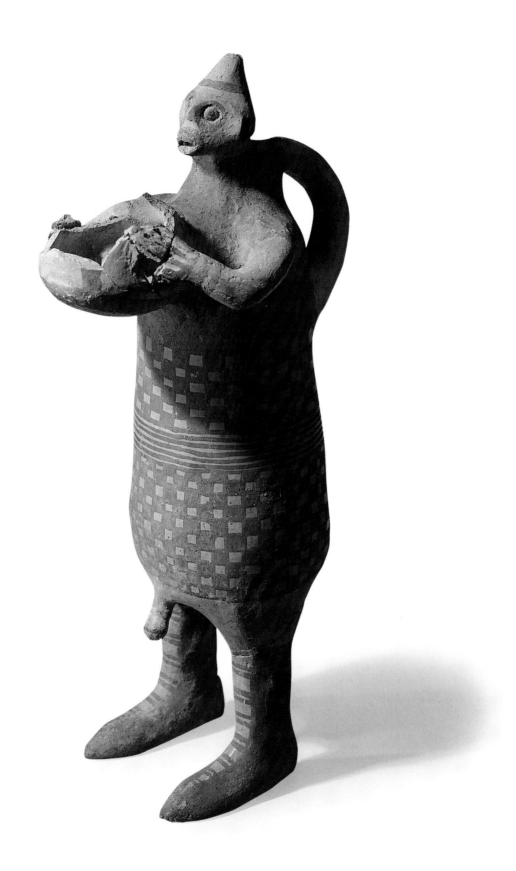

5

Amlash zebu

Iran, Gilan Province, Amlash area,
probably Marlik
1400 - 1000 BC
H 14.2cm W (between horntips) 10.3cm

Pouring vessel in the form of a zebu, burnished ruddy-coloured clay. Marks of burnishing are apparent as horizontal striations at the sides. The animal is hump-backed with crescent horns. The upper portion of its head has been left open to form a pouring spout. Horizontally aligned ears are placed either side of the spout opening and eyes are suggested by incised rings. There is a ridge down the front of the body, starting at the chin, while another similar ridge forms the tail.

The humped-zebu vessel is one of the most admired types from northern Iran of this period; its sculptural qualities interestingly anticipate some popular types of 20th century sculpture. The emergence of such objects from the Amlash area of Iran, in the province of Gilan, has been well recorded in the works of Ezat Negahban, who excavated the site of Marlik in the area of Rudbar.

This particular vessel was a prized possession of Raffi Soleimani, who obtained it directly from Amlash, Gilan. It is in outstanding condition.

Comparative material
Hennessy 1979, pl. 100; Moorey 1987, p. 40 (both these illustrate examples from the Ashmolean Museum, Oxford, nos. 1964.347-8); Negahban 1977, p. 50, cat. no. 91, pl. XIV, fig. 91; Kiani 1978, pp. 234-5, pl. 29. In this last example the zebu has gold earrings as do certain other figurines of its period.

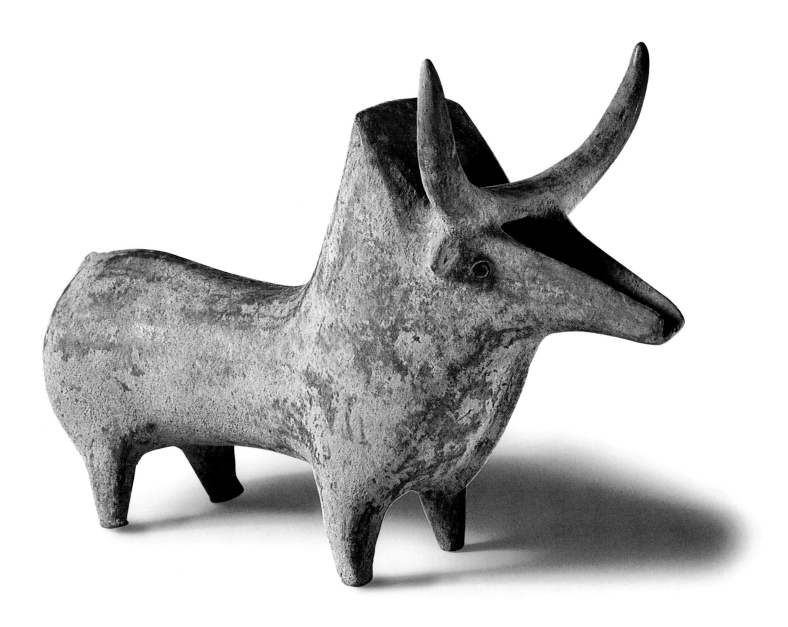

6

Amlash fertility goddess

Iran, Gilan Province, Amlash area,
Early first millenium BC.
H 46.3cm

Powerfully designed figurine of a woman, of orange baked clay with a partial surfacing of pale buff. She has a tubular, quasi-conical neck rising to a corded and notched cap, which might also be intended as a hair arrangement of braids, and which surrounds a tubular aperture to the interior. At the front of the neck element is a pad-like mask forming the face, behind which are pierced ears.

Arms of the figure are held against the body over the waist, with one hand placed above the other, and with wrists striated to indicate bracelets. Tapering legs join to swollen hips like inverted cones. Knees are indicated by concentric circles, which also serve as navel, shoulders and eyes.

This strongly imposing figure is larger than many of its school, which flourished in northern Iran in the region of Amlash which includes the productive locality 'Kaluraz', and which is near the Caspian Sea. The feel for rhythm indicated in the arrangement of its components makes this particular ceramic one of the major examples of its type.

The Toledo Museum of Art (1987.186).
Published Kurt T Luckner, Toledo Treasures.
Selections from the Toledo Museum of Art,
New York 1995.

Comparative material
Fukai 1982-3, nos. 9, 11, 12. Lawton 1987, cat. no. 32.
Kawami 1991, pp. 154, 155, no. 58.

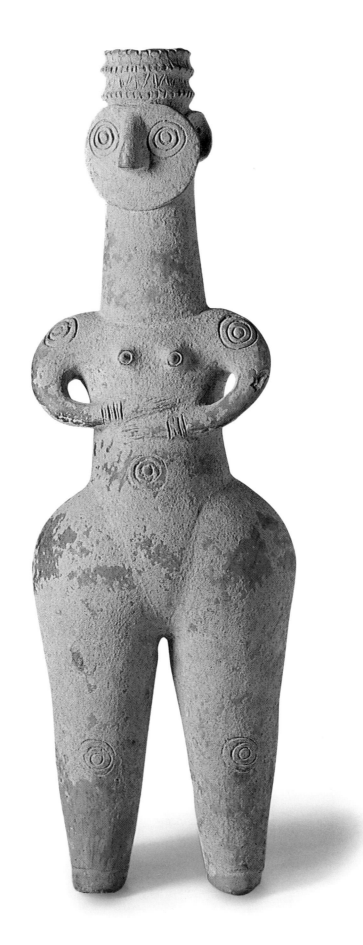

7

Pair of goat-shaped rhyta

Central Iran, possibly Luristan

10th - 8th century BC

H 15.8cm, 16cm

A pair of goat-form ceramic rhyta, in peach-tone clay, the animals depicted with legs tucked beneath them as if leaping. The upper rims of each rhyton are outsplayed, and there is painted ornament on the walls and bodies of each goat in red-orange and deep brown, including striation of the horns.

The walls of both vessels are painted with flag-form chevrons, some of which are edged with double lines, while others are filled in with criss-cross patterning, which also ornaments other portions of the design. The criss-cross is typical ornamentation on ceramic vessels of Tepe Sialk, Central Iran, produced from the 9th to the 7th centuries BC,

which are known to carry sculpted additions at times, though rarely of the naturalism of these goats. The design of the goats suggests the foreparts of leaping mountain goats used to ornament the whetstone handles of Luristan, produced around 1000 BC.

Hirayama Collection, Kamakura

Published Fukai 1982-83, no. 128, pl. 128, p. 290, fig. 57.

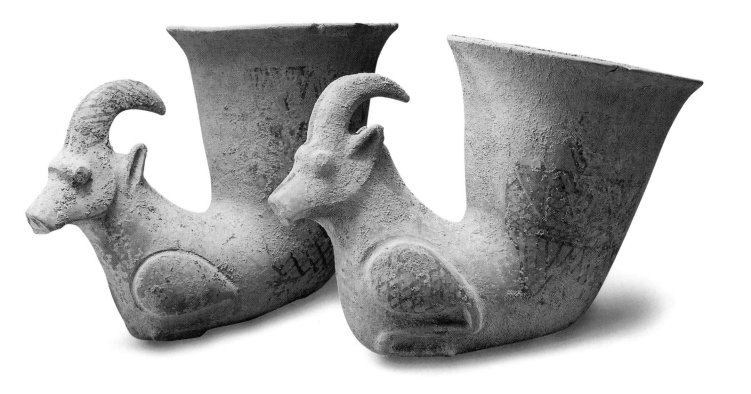

8

Amlash fertility goddess

Iran, Gilan province, Amlash area

early first millenium BC
H 38cm W 11cm

Figurine of a woman, hollow, ruddy-coloured baked clay. The figure has greatly exaggerated hips and buttocks and rather wide legs. A mask-like disc serves for a face; there is a beak-like nose, and a double, rope-like band at the base of a cylindrical hat. The hands of the figurine are held just below its jutting breasts. Each ear is pierced by two rings, one above the other. What is probably meant to be hair, but might possibly be a woven appendage to the head-dress, descends in a ridge marked with chevron-incisions from the top of the back of the head-dress to between the shoulders. There is a pattern of concentric circles over the body; these form eyes, ornaments at the front and back of the shoulders, the navel, and an ornament on each thigh. A series of incisions edge each foot and serve more as a decorative border to the feet than as a naturalistic indication of toes, since they continue along the sides of each foot.

A number of these figurines have been uncovered in northern Iran. None of this exact type, however, have been found in the excavations at Marlik in the Gilan-Amlash region, a site which mainly dates to the late second millennium BC. They are most probably somewhat more recent and are perhaps best dated to the early first millennium BC. Versions of their layered, horizontally-corded head-dress appear on various decorated bronze tubes from Luristan which also take the form of women with their hands placed below their breasts and are now usually given a date of 8th-7th century BC (see, for instance, Moorey 1971, no. 86). Nevertheless, the vertically-placed piercings in their outsplayed ears carry on a Near Eastern tradition which began in the second half of the third millennium BC and survived through the second. There seems to be little evidence that this tradition carried on very far into the first millennium BC.

Comparative material
Lawton 1987, cat. no. 32, illustrates a related figurine in the Sackler Gallery, Washington, which has the same concentric circles on the surface of the body. Fukai 1982-3, no. 9, 10.

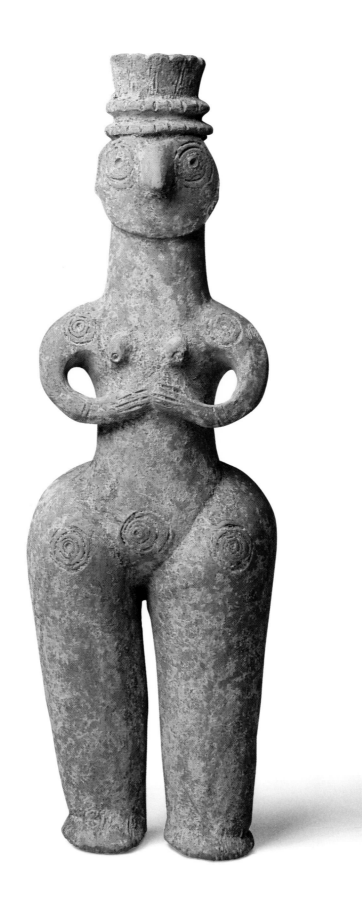

9

Fragmentary Amlash fertility goddess

Iran, Gilan province, Amlash area
circa 800 BC
H 21.6cm W 12.5cm

Fragmentary figurine of a woman, hollow, ruddy-coloured baked clay. The wide cylindrical neck narrows into a tall head-dress, decorated with three incised bands resembling cords. The ears are outsplayed and each has two holes pierced, presumably to carry earrings. The face consists of an applied pad, resembling a mask, with a jutting, beak-like nose and eyes, each of which is made of three concentric rings. A pad attached to the back of the tall head-dress, descending towards the middle of the back, may indicate a concern to represent a current hair-style, but given the relative crudity of the stylizing of facial features this is by no means certain.

This figurine displays a somewhat greater concern with naturalism than many of the other figurines of this well-known group. The arms, which loop to either side of the figure, differ from the ones seen on object no.5 in this catalogue, in that they are given definite points at the elbow. There are also distinct ridges in the positions of scapulae and indications of the spinal cord at the figure's back.

Comparative material
Lawton 1987, cat. no. 32, for an example with the same head-dress; Fukai 1982-3, nos. 9, 11, 12, are somewhat similar figurines having the same hand positions as this example, but lacking its pointed elbows.

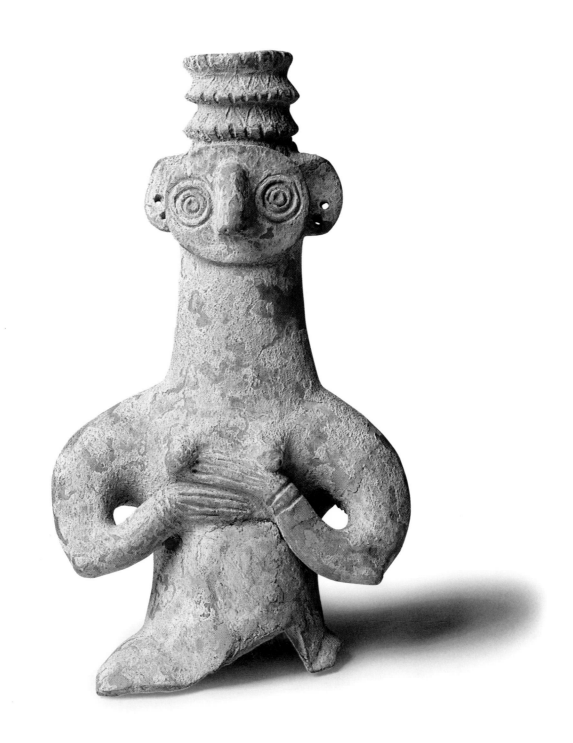

10

Luristan tripodal jar

Iran, Luristan

c. 900 - 700 BC

H (vessel) 38cm H (figure) 24cm

Part of a tripodal jar with figurine attachment; buff-coloured clay painted with chocolate-brown designs. The large jar-fragment has been skilfully incorporated into a vessel which follows what would doubtless have been the original form. The fragment has upright sides which angle inwards in the direction of the rim. To one side is attached a male figure, wearing a helmet or hat with one arm extended and holding what seems to be an upright container with an open end. The figure is represented wearing a close-fitting garment, marked with brown dots. It has outsized feet with laced shoes, the soles of which curve up to form points. The uppers are seamed, and then tied at the ankles. The face has an unusual stylization with simple planes indicating the configuration of the chin, the angles of the cheeks and the ears. Circles intended as eyes which were once marked either side of the nose are now rather indistinct.

Around the walls of the vessel, to deduce from what remains of it, were painted parallel bands of interlocking arches, with the downward-directed triangles thus produced completely filled in for two of the rows, and with hatched filling in the row between. This is a typical design used in Luristan ceramic-painting in the period of Iron Age II, around 800 BC – the style called 'triangle ware' or the 'genre Luristan', which has sometimes been compared with the appearance of a bridge. The lowest band of decoration originally contained concentric circles surrounded by short rays, alternating with a vertical patterning composed of straight lines and scallops. A similar type of design is seen on the one remaining foot.

Tripodal jars and other ceramics with this sort of geometric decoration are well known from the Luristan region in Iron Age II, but this remarkable piece with its addition of a human figure seems so far to be unique. Examples of vessels with similar geometric designs of the period mentioned were uncovered from Baba Jan Tepe, Luristan, by Claire Goff, and can be seen in the Ashmolean Museum, Oxford. Another well-known example in the British Museum (1131072) is from Ramishkan, Iran.

Comparative material

Godard 1965, pl. 8, shows a similar tripodal vessel with one handle, but without any attached figure; Hennessy 1979, pl. 103, shows a tripodal jar with a simpler hatched design; Kiani 1978, pl. 15, illustrates a jug from Sialk of the first millennium BC which has the chequer-board and geometric designs of the man's costume.

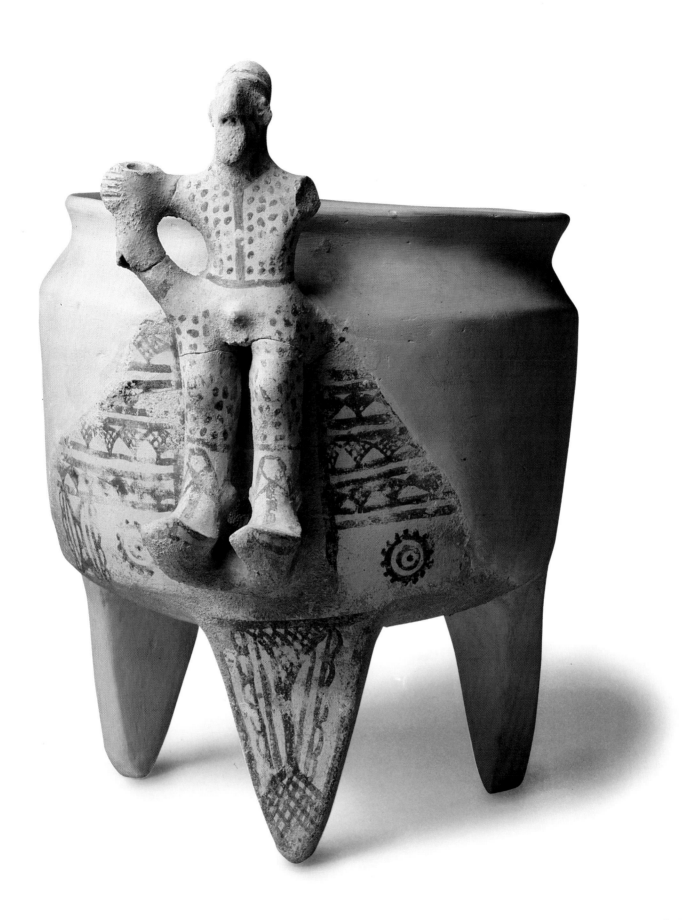

11

Amlash figurine flask

Iran, Gilan province, Amlash area
circa 800 BC

Rare figurine of a woman, of orange-baked clay. The powerfully exaggerated, bulb-form hips and legs rise to a columnar element, open at the top, forming the torso and head, and indicating that the entire piece may once have functioned as a flask. There are rudimentary arms and small, knob-form breasts, with a row of horizontal lines encircling the neck. Pierced ears are placed higher than the applied, oval pad which takes the form of a face in semi-relief, with incised, circular eyes. The buttocks of the woman are stylized as protruding hemispheres, placed to the rear of her massive hips and legs. At the front, feet are suggested by notches indicating toes.

This figurine is the most strongly developed example of a sequence of such figurines found at Amlash, Iran, which are all variants of this type, and of which five now in Japanese collections have been published by Shinji Fukai (1982-3, nos. 15-17, 20, 21). Of these, one stands on a lion, and is surely the representation of a goddess (Fukai 1982-3, no. 21).

The stylization of this particular example can be read as the combination of a phallus and a woman, which is of course an appropriate stylization for a fertility goddess, which this figurine most probably represents.

Although the exaggerated hips of the figurine have no parallels in bronze, the upper, tubular portion shares the ringed neck, high loop ears, pad face, cap-form and small arms with the design of Luristan bronze staff-form figurines produced in Iran in the earlier first millennium BC, well to the south of the production area of this piece (Moorey 1974, p. 114, nos. 87, 88).

Private Collection

Comparative material
Fukai 1981, pp. 247, 248, pls. 15-17, 20, 21.

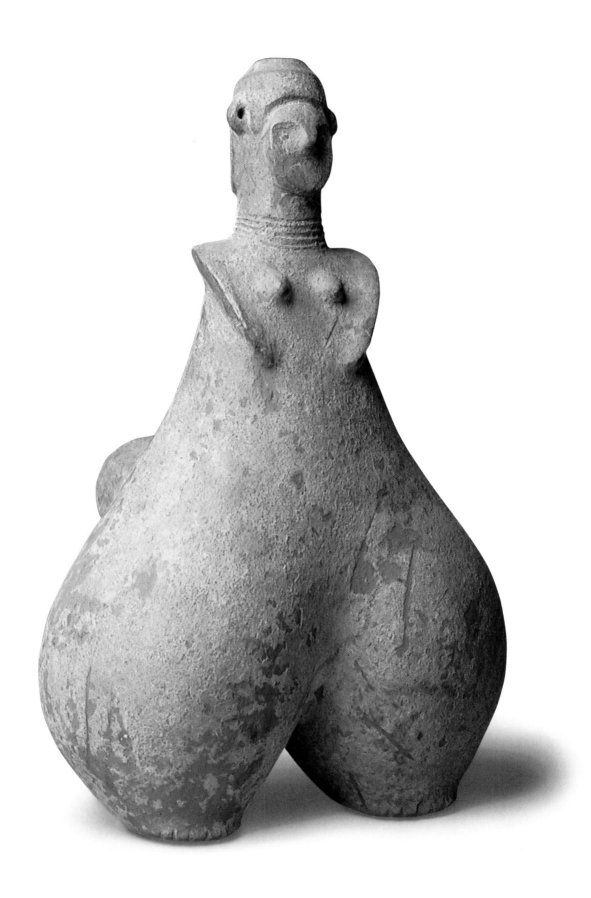

12

South Arabian female portrait head

Yemen, Qataban, Timna,

necropolis Haid bin 'Aqil,

3rd -1st century BC

H 29.5cm W (at ears) 11.7cm

W (at base) 8.2cm

Portrait head of a woman, of South Arabian type, translucent pale yellow alabaster with opaque orange, brown, tan and translucent white veins. The veining is concentrated at the back of the head and is clearly arranged to provide colour to the hair when the head is viewed from the front. The head is poised on an elongated, quasi-columnar neck, which takes up almost half the total height of the piece. The brow line and the line of the top of the head are flattish and somewhat angled at the temples. There are rather elongated ears set above lobes of hair which flare out at each side of the cheeks. The texture of the hair is suggested by horizontal cuts and by rough tooling of the surface of the stone. A flat area of the back of the head has been left unworked and was certainly not meant to be seen, which perhaps suggests that the piece was once in a niche of some kind or placed against a wall. The eye sockets are deeply hollowed and would once have contained inserts probably made of a combination of bitumen and shell (a head in similar style with these inserted eyes can be seen in the Museum für Völkerkunde, Munich). One eyebrow is slightly higher than the other, giving the face, to modern eyes at least, a somewhat quizzical look. The slightly aquiline nose meets the brow without a break, and is

perhaps a little reminiscent of the Hellenistic-Roman style popular elsewhere during the period. Small vertical lines to each side of the small, well-shaped mouth give the hint of a smile.

This head is, in fact, one of the finest of a less than well documented group of such objects, which were being produced on the fringes of South Arabia in the last centuries of the first millennium BC. It reportedly came originally from Haid bin 'Aqil – the necropolis of Timna, the capital city of the historic state of Qataban, now part of South Yemen. The personage depicted is beardless, in contrast to the subject of object no. 13, who has a fringe-beard round the outer edge of his chin. At first glance there appears no definite way to determine whether this present head depicts a woman or a young beardless male. However, all the bearded heads which survive appear to lack the lobed arrangement of hair at either side of the chin, while a rare full-figure sculpture which does exhibit this hairstyle, and which was sold at Christie's in July 1971 (lot 258), clearly depicts a female, with obvious breasts. Thus the present head most probably does represent a woman.

Detroit Institute of Arts

Comparative material
Related examples are in the Louvre, Paris, the Museum für Völkerkunde, Munich, and the Islamisches Museum, Berlin; see Caubet 1990, p. 40, cat. no. 5; Daum 1988, pp. 48, 87-89; Radt 1973, pp. 14, 15, pl. 23; Moorey 1987, p. 41, fig. 39.

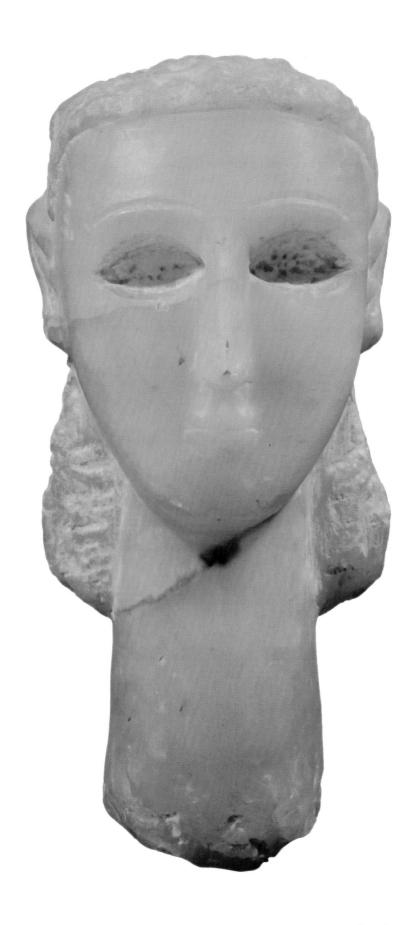

13

South Arabian male portrait head

Yemen, Qataban, Timna

3rd - 2nd century BC

H 29cm W (at ears) 14cm

W (at base) 8.7cm

Portrait head of a bearded man, South Arabian type, translucent alabaster with brown veins. The alabaster is fine-grained and has very little surface pitting. The head is flat and rather rectangular at the top. It is carved in gentle planes and a heart-shaped concavity around the mouth gives a pleasingly soft expression to the face. The nose descends in an unbroken line from the top of the brow. The eyes have been incised to accept inlays and take the form of pointed ovals some 4mm deep; they are emphasized by a narrow hollowing under each. The right eye is slightly larger than the left, a detail which may relate to the actual appearance of the sitter. The eyebrows take the form of triangular incisions and might also perhaps be designed to contain inlays. The frame of hair surrounding the face and forming the beard is roughly carved, and textured by short strokes of the tool. The same technique is used at the interior of the eye-sockets, doubtless to give purchase to the adhesive which held the inlays, and also at the back

of the head and at the base of the neck. The neck was perhaps set into a base of another material and the sculpture originally backed against a flat vertical surface. The ears are rather simply composed of a form like a letter C with a knob within its enclosure. Such sculptures are among the most familiar and most highly prized products of the South Arabian fringe, the area which now lies within Yemen. This bearded type of portrait-head, however, has not been documented in controlled excavations in Yemen and in spite of its undoubted aesthetic power is less well represented in major museums than the beardless type, e.g. object no.12, to which it obviously relates. Other examples of this bearded type of head were to be seen in sale-room catalogues during the 1970s, during which period these pieces were probably emerging from Yemen.

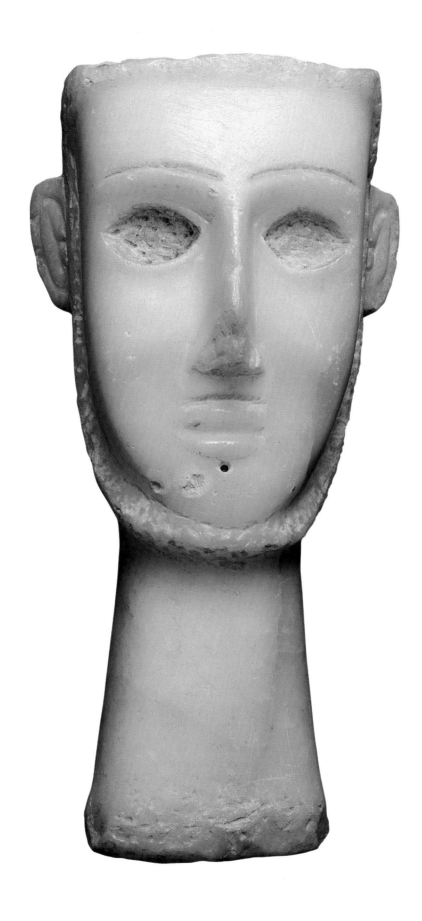

GLASS FROM THE ANCIENT WORLD

The fine pieces of early glass in this volume, notable for their intrinsic beauty and interest, are also a reflection of the long friendship which existed between Raffi Soleimani and the great Japanese archaeologist and expert on ancient glass, Shinji Fukai. The group is particularly rich in small, core-formed unguent vessels from the Eastern Mediterranean, of the type dating from the sixth and fifth centuries BC. Three closely related examples, 15, 16 and 17, were once in the well-known Breitbart Collection and are preserved in excellent condition. These probably derive from a single workshop. All have a base colour of dark blue, attractively translucent, and are decorated with bright opaque trails of corn-yellow and turquoise, some of which have been dragged up and down with a tool in order to form zigzags on the bodies of the vessels. All three pieces are very close to examples from another group in the British Museum which are, according to recent research, believed to have been made at a single workshop in Rhodes, and it is probable that all these pieces were made at the same time and place. Not only have many such vessels been found in graves in Rhodes, but there is also evidence that the area was a centre of production for the scented oils and unguents believed to have been contained in vessels of this type (Tait 1991, pp. 42-3).

Another piece of great interest is object no. 18, an oinochoe jug with a trefoil lip, contemporary with the above group. Said to have been found in Etruria, it may represent a Syrian core-formed type. Its sophisticated zigzag banding, with fifteen rows of trails in colours of corn-yellow combined with opaque and transparent white, demonstrates a high level of production control.

It is most appropriate, in the context of this volume, that there should appear a particularly splendid Iranian example of core-formed glassmaking. We thus include the beautiful and highly unusual Achaemenid kohl-tube, object no. 19, which dates from the 5th or 4th century BC. The enhancement of the tapering, rectangular shape by the 'capping' of the four corners with additional glass gives the piece an architectural feel and a repetition of the same treatment at four points on the collar - a rare 'improvement' to a standard design - gives the collar as well as the body a rectangular section. It has been suggested that this type of shoulder-enhancement may relate to the projections found on horned altars in the ancient Near East (Grose 1989, p. 79), although a remote connection between this shape and the shapes of Egyptian rod-formed kohl-tubes of the New Kingdom, made in the form of palm-columns where the shape tapers downwards from flaring projections at the shoulders, should not be ignored. Although now generally attributed to western Asia, i.e. areas within the confines of the Achaemenid-Persian Empire, this kind of kohl-tube has been found at its northern peripheries, in northwest Iran in Azarbaijan, Georgia and Turkey.

Another outstanding piece from the Achaemenid sphere of influence is the beautiful phiale, object no. 20. It is one of a fairly small group of surviving pieces of this design with an

exterior decoration, moulded and cut, of between sixteen and twenty petals. These pieces seem to imitate a design for shallow bowls in precious metals and it has been argued that they represent a fairly short-lived fashion of the period c. 400 BC. The piece seen here is particularly distinguished, having sixteen petals, and while some of the other examples show a certain carelessness in the post-cooling cut decorative additions, e.g. with several starting and stopping places for the incised line beneath the rim, in this example all the enhancements are done with great elegance.

The slightly later, early-Hellenistic, period of core-formed vessel-making is represented here by object no. 21, a charming, squat alabastron with a disc-form rim tooled into shape and vertical handles which were probably pre-formed as beads. Its side wall carries a feather design in white, anticipating the trailed and marvered patterns made by the same technique of surface decoration on mediaeval Islamic glass almost two thousand years later.

One of the most sensational glass objects in the present collection, object no. 34, is a piece of mould-blown honeycomb glass, in the form of a low bowl: the base is covered with a precisely-formed honeycomb motif and the side wall has forty-eight vertical ribs. This piece has been published before and is quite well known, having been admired for many years in its former home in the Kofler-Truniger Collection. Its only close parallel is another bowl in the Toledo Museum of Art, Ohio, which is, however, not so

perfectly formed. There is again the possibility that the present piece and the Toledo example are products of an interrupted production process and represent unfamiliar interim forms of vessels familiar in their final forms. This has not been established, however, and the matter is discussed more fully in the entry for the bowl.

Another extremely striking piece is the Canosa bowl, object no. 23. In this instance it is the astonishingly vibrant blue of the glass material which draws the eye rather than subtlety of form. Indeed, amongst the very small group of surviving footed bowls in this repertoire, this seems to be the only one to be made from glass of a very strong colour.

The assemblage of ancient glass presented here is filled out with a number of impressive items belonging to the Roman Imperial period, such as the two magnificent globular long-necked sprinkler-flasks in plain colours which are 'marbled' in white (object nos. 30, 31), and an attractive snake-thread flask which was also formerly in the Kofler-Truniger Collection (object no. 32). To provide some continuity with the next section of the volume there are two fine Sasanian pieces: a thick-walled cylindrical bowl (object no. 38), and a hemispherical faceted bowl of the precise form of the one which has been preserved for many centuries in the Shoso-in treasury at Nara, in Japan (object no. 37). Finally, we include an extremely decorative piece of nineteenth century furniture: a table-top in which a vast quantity of glass fragments from the Roman period has been put to a new and original use (object no. 40).

14

Mesopotamian pendant

Nuzi, northern Mesopotamia
mid-15th to early 14th century BC
H (including flange) 6cm W 5.4cm
Thickness 8mm

Pendant of cast turquoise-coloured glass in the form
of a disc. The piece is undecorated and has a
horizontally-pierced flange at the top for suspension.
The surface of the pendant is heavily corroded and
pitted, with traces of white and golden weathering
film which is attractively distributed within the pitted
areas. The turquoise colouring of the glass and its
round shape would probably have had celestial
connotations related to those of the solar disc-
pendants in gold which were being made at the
same time as glass of this type, and which help to
date it. Glass versions of these gold discs are
amongst Hurrian material discovered at Nuzi in
northern Mesopotamia, east of the Tigris, where
plain turquoise glass pendants resembling this
present piece were found (see Goldstein 1979, pp.
47-48).

Comparative material
Starr 1939, p. 452, pl. 120, for the material from Nuzi;
Goldstein 1979, p. 47, no. 2, for a similar pendant in the
Corning Museum of Glass.

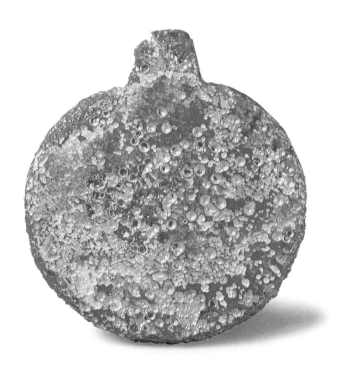

15

Core-formed aryballos

Eastern Mediterranean, perhaps Rhodes

6th - 5th century BC

H 6.1cm D(maximum) 5.2cm D(rim) 2.6cm

Unguent flask (aryballos). A core-formed glass vessel of translucent deep blue glass with a high sheen. The quasi-globular body has a gentle point at the base. There is a short neck like an inverted cone, flaring to a lip which is edged with an unmarvered, turquoise-blue trail. Further trails of opaque corn-yellow and opaque turquoise are used to decorate the side wall in a striking zigzag arrangement bounded above and below by horizontal threads of corn-yellow glass. A pair of vertical ring-handles with tails at opposite points on the neck are composed of streaky brown glass, apparently made by mixing the yellow and turquoise glass batches.

Formerly Breitbart Collection

Comparative material

Grose's Mediterranean core-formed bottles Group I, Aryballos Form I: 1a; Harden's Form 1A. See Grose 1989, pp. 99, 151, no. 119; Harden 1981, pp. 58-59. A closely similar aryballos in the British Museum, Harden 1981, no. 258, is illustrated in Tait 1991, p. 42, fig. 45; for a piece in a Swiss private collection in Lucerne, see Lucerne 1981, p. 50, no. 87.

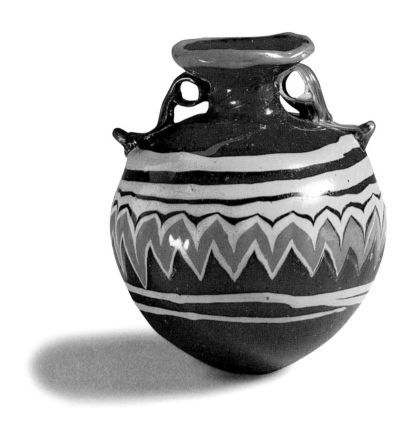

16

Core-formed aryballos

Eastern Mediterranean, probably Rhodes

6th - 5th century BC

H 6cm D(maximum) 6cm D(rim) 2.5cm

Unguent flask (aryballos), core-formed of translucent deep blue glass with opaque trails. The gently ribbed globular body has, in contrast to object no. 15, a completely rounded bottom. The short outsplayed neck is ornamented with several marvered opaque yellow trails and is edged with an unmarvered yellow trail. There is a zigzag arrangement of alternating opaque turquoise and corn-yellow marvered trails round the body, which has been ribbed after the marvering was completed. Vertical ring-handles in dark blue, with tails shaped like the lower, open portion of an S support the narrow part of the neck at opposite points.

Formerly Breitbart Collection

Comparative material

Grose's Mediterranean core-formed bottles Class I; Amphoriskos Form I: 2; Harden's Form 2. See Grose 1989, p. 145, no. 101, and Harden 1981, pp. 58, 59. Other examples: the Toledo Museum of Art 23.147; the Corning Museum of Glass 51.1.104: Goldstein 1979, p. 125, no. 259; pieces in Swiss and German private collections: Lucerne 1981, nos. 81-87.

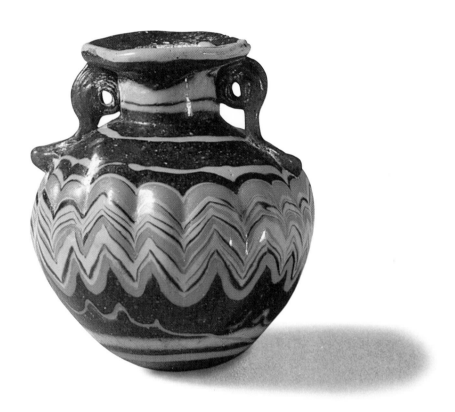

17

Core-formed oinochoe

Eastern Mediterranean, probably Rhodes

6th - 5th century BC

H 11.5cm D(maximum) 7cm

D(base) 3.8cm

Unguent bottle (oinochoe), core-formed of translucent dark blue glass, with opaque trails. The vessel has an ovoid body, a low cylindrical neck and a rather thick handle of the same coloured glass as the body which joins shoulder and lip, and stands on a low conical foot-ring. It is ornamented with both marvered and unmarvered trails in opaque corn-yellow and turquoise blue glass. The trefoil-form rim and the foot are edged with unmarvered trails of turquoise blue, and a narrower, similarly unmarvered, trail of corn-yellow girdles the neck slightly above its base. Marvered trails are applied to the body of the glass. There is a rich arrangement of golden-yellow bands round the side wall at the centre of which are two zigzag bands of turquoise blue which flank a corn-yellow zigzag.

Formerly Breitbart Collection

Comparative material

Grose's Mediterranean core-formed bottles Class I; Oinochoe Form I: 2A; Harden's Form 2A. See Grose 1989, pp. 96, 149, no. 114; Harden 1981, pp. 59, 60. The closely similar British Museum oinochoe, Harden 1981, no. 231, is illustrated in colour in Tait 1991, p. 42, fig. 45; an example in a Swiss private collection: Lucerne 1981, p. 50, no. 93.

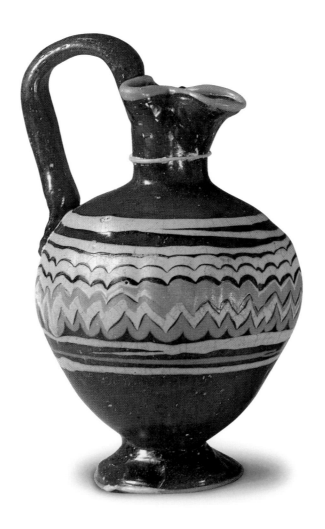

18

Core-formed oinochoe

Eastern Mediterranean, probably Syria.
Reportedly found in Etruria
6th - 5th century BC
H 6cm D(maximum) 4.2cm
D(base) 1.9cm

Unguent bottle (oinochoe), core-formed of translucent blue glass, with ornamental trails, a pyriform body and trefoil lip. The vessel stands upon a short conical pad foot. There is a slim handle of the same blue glass material as the body of the vessel joining the shoulder to the rim and folded back at the rim into a thumb piece. A narrow, unmarvered trail of corn-yellow glass edges the lip and two more such trails encircle the neck. The side wall displays a broad, tightly ornamental frieze consisting of fifteen trails of opaque white and yellow glass combined with trails of translucent white glass dragged together into a zigzag design.

Formerly Kofler-Truniger and Breitbart collections

Exhibited Lucerne, 3000 Jahre Glaskunst, Kunstmuseum, 19 July-13 September, 1981; see Lucerne 1981, cat. no. 108

Comparative material
Grose's Class I: 2A, Oinochoe Form I: 2A; Harden's form 2A. See Harden 1981, pp. 59, 60. The unusually crowded side-wall ornamentation is perhaps best paralleled by the decoration of the Corning Museum's trefoil oinochoe where again only white and opaque yellow trails are present. Goldstein thinks that this Corning vessel most probably derives from Syria: Goldstein 1979,
p. 128, no. 265.

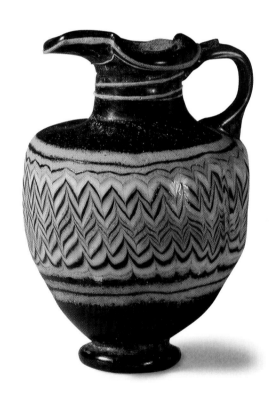

19

Achaemenid Core-formed kohl-tube

North west Iran, possibly the region
towards Azarbaijan
Achaemenid period, 5th-4th century BC
H 8.7cm D(rim) 1.2cm
Section(base) 1.15 x 1.15cm

Kohl-tube, Achaemenid period, core-formed of
opaque 'black' glass with ornamental trails. It is
rectangular in section and has a short cylindrical
neck; lip and shoulder are enhanced at four points by
small blobs of cream-coloured glass. The body has
been wound round with closely-aligned trails in
golden-yellow, white, cream and blackish blue which
have been subsequently combed and marvered flat.

Comparative material

*The broadest study of such kohl-tubes has been made by
Dan Barag; six examples of this type, only two of which
are complete, form his Group IB (Barag 1975, pp. 27, 34,
figs. 15-19). Related examples in the Corning Museum of
Glass appear in Goldstein 1979, as nos. 207-209, on pp.
105-6. Although the 'capping' of each corner of the
shoulder with a decorative blob or eye is also present on a
number of other examples, the application of additional
blobs to the lip and neck, as here, is very rare.*

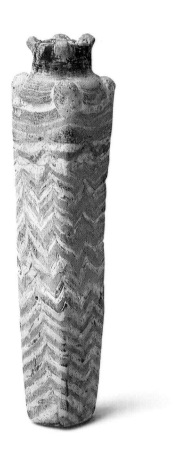

20

Achaemenid phiale

Achaemenid sphere of influence

Late 5th or early 4th century BC

H 5cm D(rim) 17.2cm

D(base-boss) 2.5cm

Shallow bowl (phiale) with everted rim, the exterior covered with patterning, the interior left plain, of nearly colourless translucent glass with a very slight yellowish-green tinge. Production was probably achieved by sagging into a mould. Tiny pits cover the surface each holding a point of iridescence, the total effect being of a delicate sheen. Some patches of brown weathering material are present, particularly round the underside of the rim. The weathering is more varied on the exterior than on the interior. The general condition is outstanding. Between the in-curving of the lower part of the bowl and the out-turning of the rim, there is a small extent of almost vertical wall. Where this joins the curved section there is a well-defined groove all round the bowl and this marks the boundary of the decoration. The main decorative element is a raised-leaf rosette which occupies the entire lower area of the bowl's exterior and which consists of sixteen petals radiating from a central disc which forms a base. Each petal-shape has three grooves, the boldest and longest being the medial one. The central disc is simply moulded, but the petal-grooves seem to have been deepened with a tool after mouldering and cooling. The groove which runs around the body of the bowl towards the rim seems to have been made with a rotating wheel with only one starting-and-stopping point apparent.

There are several other examples of phialai in both glass and metal which place this piece in context; it could have been made in any part of the Achaemenid empire. The theory that the elaborate glasswares of the Achaemenid repertoire almost invariably imitate luxury metal vessels is widely accepted, but the glass pieces are sufficiently numerous to form a distinctive group. The most important parallel for this piece is a glass phiale in the British Museum, now dated to the late 5th or early 4th century BC, having previously been misdated to a much earlier period. In an important article which deals with the whole matter of Persian export glass, Andrew Oliver discusses the British Museum vessel within a group which also includes one at Corning, which has sixteen petals (alternately with medial grooves and medial ridges); one in Cologne, which has nineteen petals; one in New York, with twenty petals; and a fragmentary example, also in the British Museum, which was found at Ephesus. The excavation-context of the Ephesus piece gives it a date no later than 350 BC and Oliver argues cogently that the pieces are unlikely to have been made much before 400 BC. He illustrates a second group of Achaemenid vessels characterized by fluted rather than petalled decoration which he claims should be seen as typical of the period around 430 BC. His conjectures have been supported by several more recent finds for both his groups.

Comparative material

Oliver 1970 deals with most of the comparable Persian glassware. The British Museum's example is published in Barag 1985, vol. I, pp. 57, 68-69, no. 46. Grose 1989, pp. 70, 80-81, fig. 48, p. 87, no. 34.

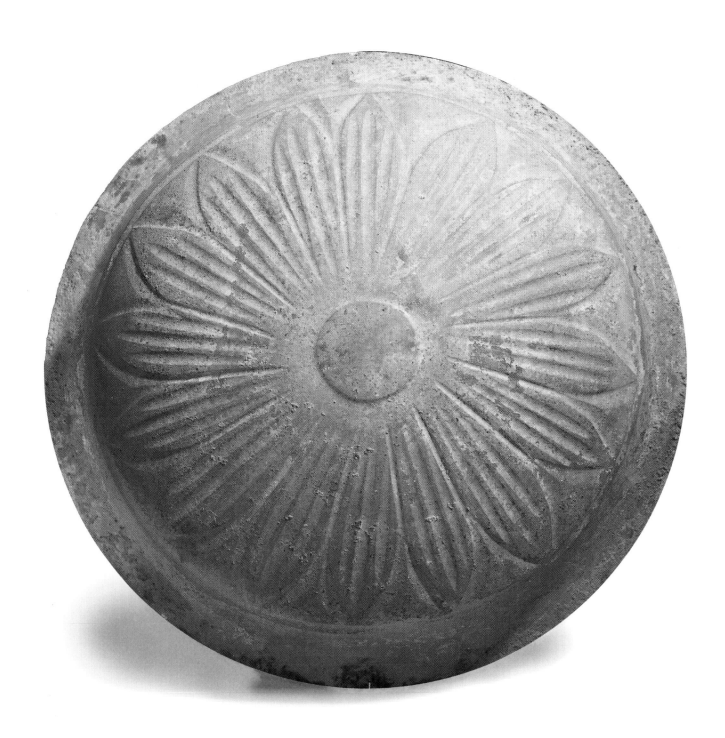

21

Core-formed alabastron

Eastern Mediterranean

4th - 3rd century BC

H 4.4cm D(maximum) 3.8cm

D(base) 3.3cm

A wide-bellied unguent bottle (alabastron), core-formed of deep blue opaque glass, with opaque trails. The bulbous body has flat shoulders, and there is a narrow neck which flares to a wide, irregular disc-form or plate rim, the edge of which carries a corn-yellow trail. This echoes a darker yellow trail round the shoulder. The side wall is ornamented with a combed feather pattern in opaque white. The base has been marvered flat. At opposite points on the body are set vertical ring-handles, which appear to have been made from pre-formed beads.

Formerly Breitbart collection

Comparative material

This low, rather squat, early Hellenistic alabastron shape is the form classified by Grose with Mediterranean core-formed bottles II: 3 (Grose 1989, p. 131); it is in fact quite rare. Toledo has no example, and for this reason Grose, in his publication of the Toledo Collections, cites one which is part of the Hans Cohn Collection in the Los Angeles County Museum of Art (Grose 1989, p. 117, fig. 71; also Saldern 1981, p. 29, no. 6).

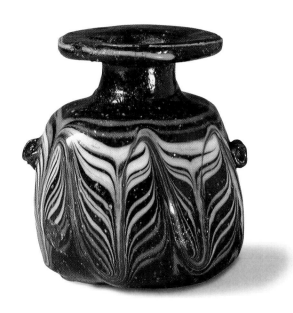

22

Core-formed alabastron

Eastern Mediterranean,
Mid-4th to early 3rd century BC
H 16.2cm D(body) 4.2cm D(rim) 4.9cm

A core-formed unguent bottle (alabastron) made from a deep blue transparent glass, which is somewhat bubbly and pitted at the base and neck. The almost tubular body, rounded at its base, tapers gently towards an angular shoulder above which is a short cylindrical neck with a disc-form rim. Small vertical ring handles are applied as S-trails. The side wall is decorated with a feather pattern of alternating groups of opaque white and opaque gold combed trails and with vertical tooling marks. The piece is in excellent condition and retains an iridescent, whitish, but virtually transparent weathering crust over much of the surface.

This general type of Hellenistic alabastron is usually found with ring handles without tails; the presence of the tails here is probably best seen as an archaizing detail, suggesting that this alabastron was created within the tradition of a large body of earlier pieces dating from the 6th to 4th centuries BC.

Comparative material

Classified by Grose as Mediterranean core formed bottle II: 3B (Grose 1989, p. 131). Examples of this important alabastron type are present in a number of collections; these include the Toledo Museum of Art (Grose 1989, p. 153, no. 125); an example which was formerly in the Kofler-Truniger Collection is illustrated as Kofler-Truniger 1985, no. 49.

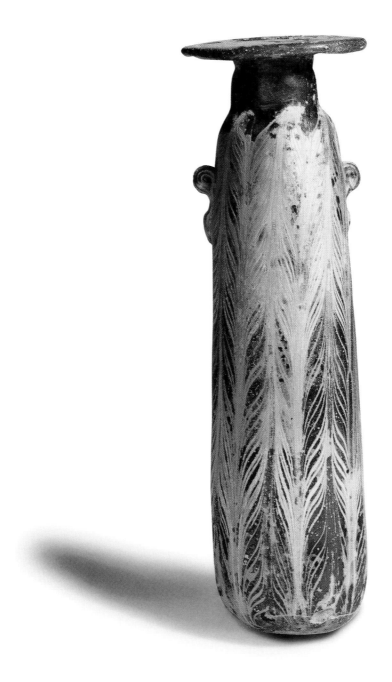

23

Canosa footed glass bowl

Italy, or Eastern Mediterranean

3rd century BC

H 20.3cm D(rim) 22cm to 22.5cm

D(base) 8.7cm to 9cm stem thickness 2.8cm

Large footed bowl of the 'Canosa Group', of turquoise translucent glass. Within the 'Canosa Group', bowls of this shape are extremely rare. The glass of this bowl is a rich turquoise blue of great vibrancy and has been cast, lathe-cut, ground and polished. The glass material is very clear with few bubbles. The outer wall is encircled some way below the rim by four closely aligned wheel-turned grooves, and there is the hint of a fifth just above them. This is the only exterior decoration above the baluster-formation and carinated moulding of the bell-formed pedestal base. The interior has a further pair of grooves just below the rim. The stem is solid and hollow beneath, with a further incised line bisecting the outer edge of the base rim, as is the case with other members of the group. There are, to judge from the literature, only four other complete footed Canosa Group bowls which have survived; like three of them (the one at Corning being the exception – see below), this piece has been broken and skilfully mended.

Canosa Group glass-wares are named from the fact that a number of them were found in luxuriously furnished graves in Italy in the region of Apulia at Canosa di Puglia (ancient Canusium). They represent the height of manufacturing achievement in the last few centuries before the development of glass-blowing. They were made in a variety of shapes, and are believed to be members of the first attested dinner services, to use the modern expression, in glass. The piece has been worked with enormous care, and there are subtle variations in the thickness of the glass, which lighten or deepen its lovely colour when the piece is seen against the light. The design is particularly interesting in that the form, which is slightly deeper than hemispherical, is absolutely simple and lacks any kind of rim. This makes the vessel unique among the Canosa Group footed bowls and it seems just possible that the piece might once have formed the bottom of a multi-part amphora, which could have been assembled with metal binding strips like the lidded example in the Antikenmuseum, Berlin (see Grose 1989, p. 188, fig. 96). This present piece is the only member of the group of five complete footed Canosa bowls to be made in strongly coloured glass, the others are of amber, or of translucent green. There are, however, a few other Canosa Group vessels, whether complete or represented by sherds only which do use very strong colours, e.g. rich blues or purple, and point to there having been a taste for such colours among purchasers.

Private collection

Comparative material

The four other complete footed bowls: the Corning Museum of Glass, 69.1.7: Harden 1980, p. 23, figs. 14-15; the Toledo Museum of Art (Toledo, Ohio), 80.1000: Harden 1980, pp. 20-21, figs. 8-10; Grose 1989, pp. 177, 187, 198, cat. no. 183; the Metropolitan Museum of Art, New York, 17.194.130: Harden 1980, p. 22, figs. 11-13; and Museum für Kunst und Gewerbe, Hamburg, 1975.53a: Harden 1980, p. 23, figs. 16-17.

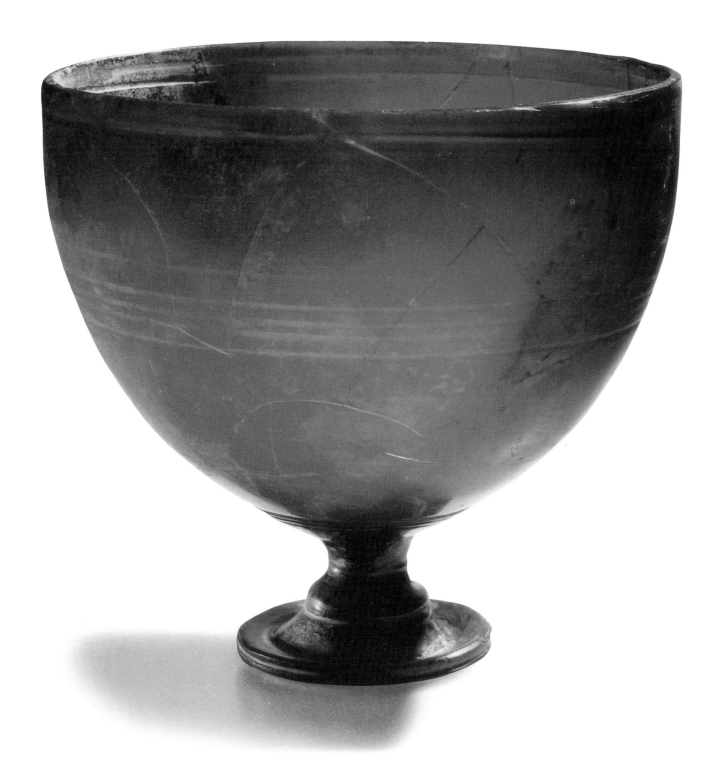

24

Gold-band flask

Eastern Mediterranean, Rome or Alexandria
Early first century AD
H 8cm W 4cm

Cast, gold-band flask (unguentarium) made of polychrome bands of glass vertically placed in an irregular arrangement – translucent dark blue, dark green, opaque white and colourless glass encasing shattered gold leaf. The upper walls of the tall, carinated and biconical body are gently concave and surmount a hemispherical base. The cylindrical neck flares into an outsplayed lip. Lathe-cut grooves emphasize points of articulation in the form – at the angular shoulders and at the point of join between the side walls and the bowl-form base. In fact, some versions of the shape were composed by casting with sand-core in separate sections which were then heated and joined at the points of articulation; wheel cut grooves enhanced the design (Grose 1989, p. 261).

The flask belongs to a peak era for the production of opulent Roman glass, the first half of the first century AD, and is a superb example of a prized type.

Private collection

Comparative material
Isings form 7 (Isings 1957, pp. 23,24). Similar vessels, probably from the same workshop are in the Corning Museum of Glass (Harden 1987, no. 17, p. 41), and the Fitzwilliam Museum, Cambridge (Grose 1989, p. 261, fig. 154). A small flask of the same sort of material, less angled in form is in the Toledo Museum of Art (Grose 1989, pp. 239, 339, cat. no. 605).

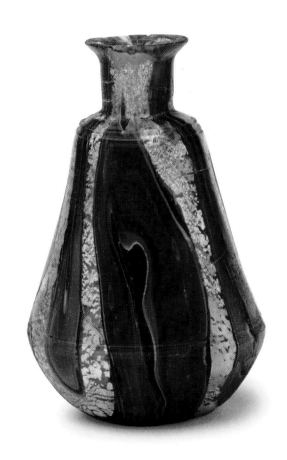

25

Blue patella cup

Roman Empire, Italy or Syria - Palestine
Late 1st century BC to early 1st century AD
H 4.3cm D(rim) 11.3cm D(base) 3.8cm

Blue glass bowl (patella cup) with carinated sides, cast and lathe-cut. The translucent, deep blue glass is handsomely iridescent and deeply pitted on the surface as a result of weathering and the subsequent loss of weathering crust, of which some fragments, however, remain. The body, which stands on a low conical foot ring, is of a deep, fairly globular form and has a bulge just below the nearly horizontal rim. These are all characteristic features of the group to which this vessel belongs.

Bowls of this shape, the so-called patella cups, which are believed to copy a metalwork shape, were mostly made in diverse colours of monochrome glass, but some were of mosaic glass (see object no. 26). The shape can be dated – 1st century BC into the 1st century AD – from the discovery in dated graves of various examples (Isings 1957, p. 17) and from reasonably precise knowledge about the types of mosaic glass from which examples were fashioned (Grose 1989, p. 243).

Comparative material

Isings's Form 2 (Isings 1957, p. 17). A very similar, only slightly smaller, blue glass carinated bowl is in the Corning Museum of Glass, 70.1.19: Goldstein 1979, p. 145, no. 300, pls. 19, 39. Another in the Toledo Museum of Art, 23.1381, is about the same size, but with less flare to the rim: Grose 1989, pp. 224, 304, no. 412. Further examples in a variety of gay colours are illustrated in Grose 1989, pp. 224, 304, 305.

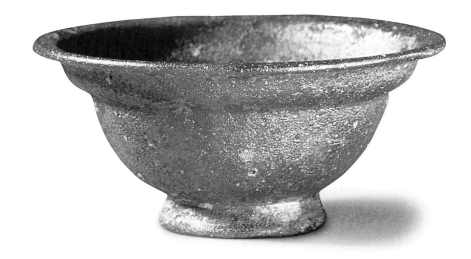

26

Mosaic ribbed bowl

Eastern Mediterranean

Late 1st century BC - early 1st century AD

H 5.1cm D(rim) 16.9cm

Cast mosaic glass, shallow ribbed pillar-moulded bowl, made of composite canes of translucent purple glass inset with opaque white glass spirals. Segments of cane were laid adjoining each other in the mould and were fused together, producing a quasi-marbled effect. Large white spirals on some parts of the glass contrast with more compact spirals nearby. The exterior carries twenty-six moulded ribs with prominent upper ends and tapering shafts, narrowing onto the underside of the concave base, where they approach each other like claws. Two wheel-cut grooves form the interior base ring, around which have appeared pin-points of lively, iridescent emerald green weathering, which greatly enhance the surrounding matt surface.

Comparative material

Isings form 3 (Isings 1957, pp. 17-19). Grose 1989, p. 248, figs. 123, 124, examples in the Toledo Museum of Art. Donald B Harden, Glass of the Caesars, London 1987, nos. 26, 27, pp. 50, 51. Hugh Tait, editor, Five Thousand Years of Glass, London 1991, pp. 58, 59, fig. 67. Winfield Smith, 1957, p. 121, no. 208.

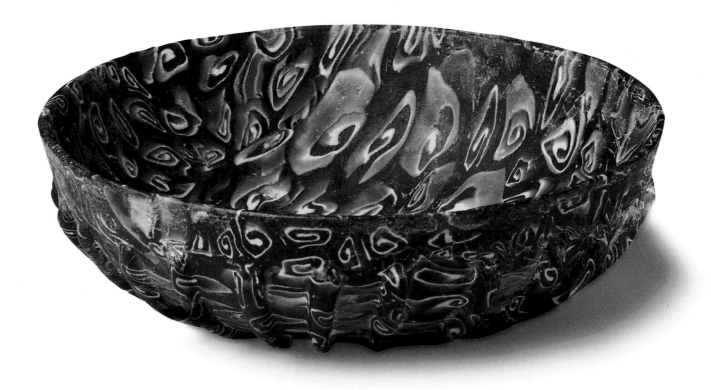

27

Cameo-glass fragment

Most probably from Italy,
1st century AD or possibly 3rd century AD
H 4.7cm D 10.1cm

Cast blue cameo-glass fragment overlaid in white, carved with a scene of putti gathering grapes. The smooth shiny underside of this fragment suggests that its basic shape was achieved in a mould. The carving seems to have involved the use of both abrasive-fed wheels and handtools; the grapes and hair seem additionally to have involved the use of a hollow drill, a most unusual feature for the decoration-technique of a piece of this date, although its use for other purposes is well attested. The peculiar shape of the preserved edge of the piece suggests that it was most likely a portion of a fairly flat vessel-handle. It might just possibly have been a cameo panel prepared for insertion into some kind of ornamental assemblage. The latter possibility is suggested by the fact that several flat cameo panels uncovered at Pompeii were thought to have been inserts for wooden furniture, functioning in the same way as the much more usual panels of ivory (Harden 1987, p. 72). The increase in thickness at the centre (to 4mm which is twice the thickness of the preserved edge) would support either presumption. The fully preserved putto on the right is dressed in a sleeved garment with what seems to be a sash round the waist and a short flying cloak. The date of the piece cannot be determined with absolute certainty, because the history and development of Roman cameo-glass production are still not well established.

Dr Sidney Goldstein has suggested in a personal communication that the fragment should probably be dated to the later 3rd century AD, or even to the 4th. This certainly accords with the costume style and the fact that grape-gathering seems to be a more prominent feature of the iconography of that period than of the first two centuries AD, when cameo-glass was already in production. On the other hand, there are earlier versions of the motif and in some ways the piece seems more at home stylistically in, say, the 1st century AD. Grape-harvesting was an action still symbolically associated in the 1st century AD with the properties of wine in transporting the drinker to another life; it was, of course, a motif soon to be adopted on Christian monuments as suggestive of the Eucharist.

Private collection

Comparative material
The most famous surviving complete vessel with similar decoration is the cameo amphora found at Pompeii in a tomb associated with the House of the Mosaic Columns; Museo Archeologico Nazionale, Naples, inv. no. 13521; this is dated to the second quarter of the 1st century AD: Harden 1987, pp. 74-78, no. 33. For other flat fragments of this type, see Lucerne 1981, p. 72, no. 227.

28

Mosaic flask

Italy

Early to mid-1st century AD

H 6.4cm W 4.7cm D(base) 5cm

Small globular flask made from mosaic glass of onyx pattern, cast and rotary-polished. The glass displays translucent golden brown and opaque white bands assembled from sections of cane. The vessel has a bulbous pyriform body and a cylindrical neck flaring at the lip. The lip itself is chamfered towards the body, and has been ground flat on top.

The delightful qualities of the so-called 'onyx' mosaic glass have been achieved by using segments of what are known as 'cowhorns', the full-sized ends of glass canes which alternate layers of brown and white and which remain after a large blob of such glass has been attached to the pontil to be drawn out into narrow canes in which the same design is miniaturized for use in other types of mosaic glass. Slicing and subsequently casting portions of the cowhorns into moulds produces successful imitations of onyx (Grose 1989, pp. 248, 249).

Comparative material

Isings's Form 6 (Isings 1957, pp. 22, 23). A gold-band bottle of similar shape is in the Toledo Museum of Art: Grose 1989, pp. 338-339, no. 605. Onyx glass is more common in the form of cast ribbed bowls than of bottles, which are comparatively rare. Two related bottles in Swiss private collections were exhibited in Lucerne in 1981 (Lucerne 1981, nos. 203, 206), and one of somewhat more elongated shape was in the Kofler-Truniger Collection (Kofler-Truniger 1985, no. 138). An open-mouthed jar in this material is in the Metropolitan Museum, New York, Bequest of Edward C Moore, 1981: Tait 1991, p. 51, no. 58.

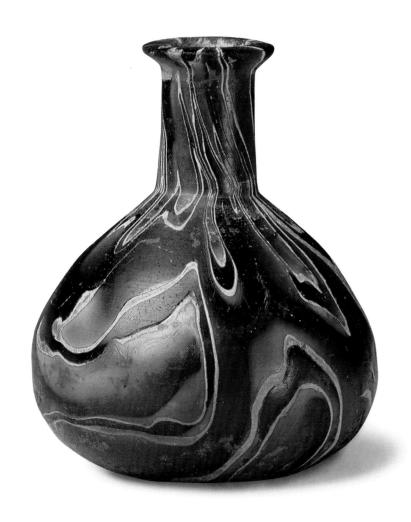

29

Pseudo - mosaic flask

Eastern Mediterranean, reputedly from Syria
1st century AD
H 8.8cm W 5.6cm D(rim) 2.1cm
D(base) 3cm

Small vessel of pseudo-mosaic glass, free-blown, with vertical bands of deep blue, white, khaki-yellow, and pale blue. The bands were applied to a gob of clear glass before blowing. The surface of the glass has not been ground, and the edges of the bands remain as tactile ridges. The flask has a pyriform body, a cylindrical neck and a narrow everted and then inward-folded rim. The base has been flattened on a marver plate; it now carries a previous collector's mark painted in white and gold.

Flasks of this sort were being made in the great transition period of glassmaking in the 1st century AD. At some times mosaic vessels with coloured stripes were simply cast, with only slight distortion of the canes from which they were composed, although in other cases, particularly where gold leaf was involved, such vessels were cast and subsequently blown, thereby inflating the preliminary cast arrangement of canes. Still other vessels within the mosaic tradition were comparatively free-blown out of blobs of glass to which either canes or bands of molten, different-coloured glass had been

applied. The name 'mosaic glass' is hardly appropriate to these, and Susan Matheson calls the examples in the Yale University Art Gallery 'pseudo-mosaic glass bottles'. Of this last group, the present example is one of the finest in the literature.

Formely Kofler-Truniger and Breitbart Collections

Published Lucerne 1981, p. 70, no. 209;
Kofler-Truniger 1985, p. 84, no. 147.

Comparative material
Yale University, Moore Collection no. 658: Matheson 1980, p. 26, no. 68; Erwin Oppenländer Collection: Saldern 1974, pp. 125, 130, 132, 133, nos. 359, 360, 366; another in a Swiss collection: Lucerne 1981, p. 70, no. 210.

30

Blue marbled unguentarium

Eastern Mediterranean or Italy

Late 1st century AD or early

2nd century AD

H 15.2cm D(maximum) 9cm

Sprinkler *(unguentarium)* of translucent blue glass, free-blown, with swirls of paler blue and opaque white giving the impression of marble. It has a long neck tapering slightly towards the everted, inwardly folded rim and a spherical body with a very faint depression under the base. This vessel and object no. 31 are quite unusual within the group to which they belong because of their nearly spherical body-forms and it is believed they were found together.

Comparative material

Clasina Isings does not include this exact shape amongst those dated examples of Roman glass which were known in 1957, but does illustrate a variety of closely related globular jugs, most of which seem to date from the second half of the 1st century AD; these are Isings's Forms 10, 26, 52 and 71 (Isings 1957, pp. 25, 40, 70, 90). Parallels seldom display such a perfect globe, although one such without the marbling of the present example was found at Stein, Houterend, Holland in 1924: Isings 1971, pp. 11, 45, no. 19, pl. 1. Related vessels in various collections: Hans Cohn: Saldern 1981, p. 44, no. 35; Swiss private collections: Lucerne 1981, pp. 71,72, nos. 219,220.

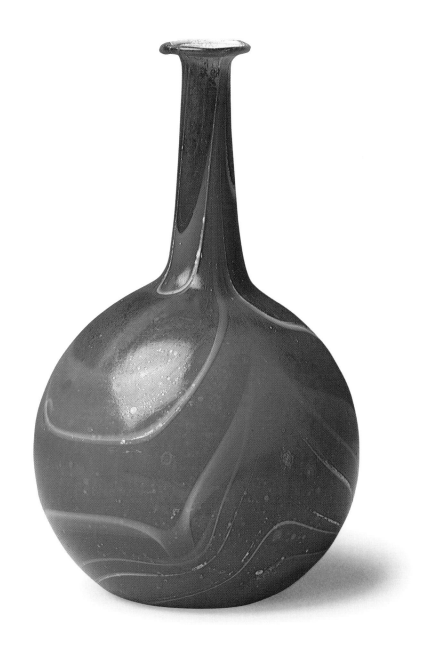

31

Purple marbled unguentarium

Eastern Mediterranean or Italy

Late 1st century AD or early

2nd century AD

H 14.6cm D(maximum) 9.3cm

Sprinkler (*unguentarium*) of purple marbled glass, globular and free-blown. The material is in fact a translucent aubergine-coloured glass with swirls of paler brown and opaque white giving the brownish marbled impression. Again, there is a long neck tapering slightly towards the everted, inwardly folded rim and a spherical body with a slightly concave base. Unusual in the same way as object no. 30, this piece was probably found with it; certainly they were acquired as a pair.

Comparative material

As for object no. 30.

32

Snake-thread unguentarium

Eastern Mediterranean, Syria - Palestine
Late 2nd century AD
H 9.1cm W 5.7cm D(rim) 5cm
D(base) 3.4cm

A 'snake-thread' sprinkler flask (unguentarium) of clear glass with a blue-green tinge, predominantly covered with silvery iridescence. The pyriform body is supported on a low foot ring of applied coiled glass. There is a flaring lip with a thickened rim rising from a bulbous quasi-cylindrical neck and pinched in at the base to create an aperture restriction of around 5mm. The body is covered with coiled decoration, milled in places with horizontal lines.

Vessels with the wandering, trailed-on coils known as 'snake-threads' – widely known from finds in the western Roman Empire area around Cologne – are also found in the Syria-Palestine sphere, and the present vessel probably originated from there (see Harden 1934). The trails are of the same colour as the body of the vessel and are tooled flat and milled in places with transverse parallel lines in a manner which seems to prefigure the rock crystal- and glass-cutting techniques, where embossed trails were again cross-cut or nicked, of the Islamic Eastern Mediterranean around the 10th century.

Formerly Kofler-Truniger collection

Published Lucerne 1981, p. 108, no. 423

Comparative material
Isings's Form 26, which was in use from the 1st century to the end of the 2nd (Isings 1957, pp. 40-41). Examples in various collections: Constable-Maxwell 1979, p. 152, no. 274; two further examples exhibited in Lucerne 1981, p. 108, nos. 423, 424.

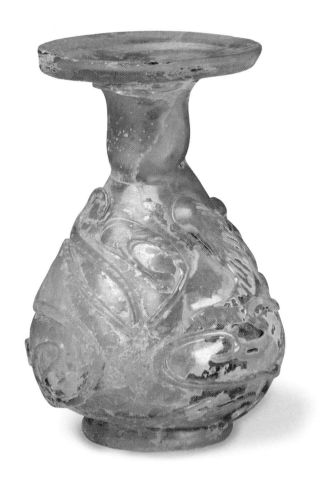

33

Tyche of Antioch flask

Syria, Antioch

2nd or 3rd century AD

H 15.5cm D(lip) 2.6cm W(foot) 4.8cm

Mould-blown glass in the form of the Tyche of Antioch, of transparent yellow-green glass which has weathered to opaque white, in the form of a creamy-white weathering crust which includes dark-red touches of manganese. The vessel copies a well-known sculpted original, and may have been designed as a town souvenir. Its type is unique among all types of Roman glass; there are no other mould-blown vessels imitating a famous work of art.

The sculpture imitated by the flask was a highly-admired work of the early third century BC made by Euthychides or Sikyon, student of the famous Hellenistic sculptor Lysippos, for the Syrians of Antioch who of course lived on the River Orontes. The sculpture represented the town's protective deity or tyche, sitting on a rock with her foot on the shoulder of a swimming youth representing the river-god Orontes. The realism of the statue was greatly admired in the ancient world, and particularly, its contorted arrangement of parts. The elaborate folds of drapery and the figure of Tyche were twisted in one direction, while Orontes' body and head were turned the opposite way.

The Tyche of this flask sits on an irregular, four-sided rock face, against which rests a bow and arrow, and a small running figure with a raised torch in one hand and a wreath in the other, usually identified with Eros, and possibly copied from the famous Tyche of Midaeum in Phrygia (Matheson 1980, nos. 276, 277).

There are nine examples known to have been preserved of this flask type, which was seemingly exported from Antioch throughout the Roman world. Four of these are now in private possession, while the five in museums consist of two at the Yale University Art Gallery (Matheson 1980, 102, nos. 276-277), and single examples at the Corning Museum, formerly in the Sangiorgi collection, at the Staatliche Museum, Berlin (Griefenhagen 1962, pp. 63, 64, no. 8; Platz-Horster 1976, p. 44, no. 69), and at the New York Metropolitan Museum. Within the surviving group of this type, this particular example is possibly the finest, being crisply moulded and virtually perfectly preserved.

Comparative material
See above.

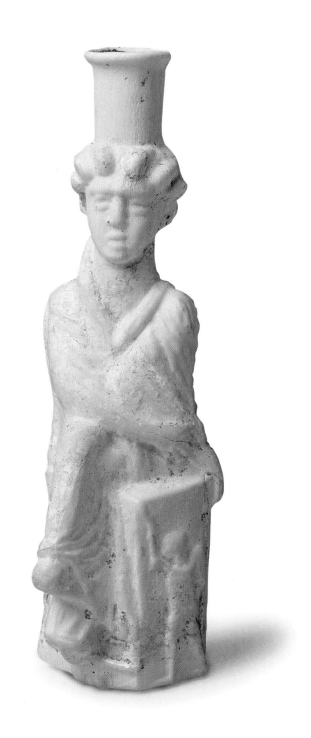

34

Ribbed and honeycomb bowl

Eastern Mediterranean, reputedly from Syria

4th century AD

H 4.7cm D 13cm

Mould-blown low, ribbed, honeycomb bowl of amber-yellow glass. The glass material is extremely clear with only a few visible bubbles. A broad, convex base is moulded into a compact honeycomb design, and an upright side wall moulded into forty-eight vertical ribs. All the moulding has been carried out with great precision and the upper surface of the rim has been ground flat. The glass has hardly been affected by weathering, although there is slight iridescence within the hollows of the honeycomb design on the exterior.

This piece – an acknowledged masterpiece of precision mould-blowing – was long admired in the Kofler-Truniger Collection. Its only close parallel is a somewhat similar bowl in the Toledo Museum of Art which is, however, not so perfectly formed. In spite of the attention this vessel has received (it was published as early as 1966 by Waldemar Habery) it remains something of a mystery. It appears in three publications among 4th century material, but its peculiarly 1st century shape, and the very high quality of its mould-blowing, have suggested that it might indeed be a 1st century production. Habery accepts this vessel and the Toledo piece as 4th century and explains their rather uncharacteristic (for that period) shape by seeing them as, in a sense, uncompleted. He suggests that they represent the first stage in production of the much more familiar tall honeycomb-bottomed, rib-walled vessel, and

that they would normally have been further blown and thus rendered less precise to achieve the final shape. The 4th century dating is almost certainly correct since the tell-tale 1st century 'hallmark' of vertical mould-seams is missing, indicating that the bowl was blown in a one-piece mould of the kind used in the 4th century. There is still the possibility, however, that its lovely design might be a deliberate 4th century re-creation of a 1st century type, rather than the result of an aborted production.

Private Collection

Formerly Kofler-Truniger collection

Published Habery 1966, p. 210, figs. 4-5; Lucerne 1981, p. 90, no. 323; Kofler-Truniger 1985, p. 31, lot 41.

Comparative material

For the shape: Isings's Form 116. A shallow plain bowl with an outsplayed rim is, in fact, not unknown as a shape for the second half of the 4th century and the early 5th; examples have been found in dated graves in Luxembourg, Belgium and the Netherlands (Isings 1957, p. 144). Clasina Isings sees them as survivals from the Roman period, and indeed the type which is not seen after the early 5th century. For the Toledo bowl, which is this vessel's closest relative, see Habery 1966, p. 209, fig. 3. 4th-century parallels of a more typical design for that period, also combining mould-blown honeycomb bases with vertical ribbing, are illustrated in Habery 1966, p. 208-212, and in Saldern 1981, p. 55, no. 62.

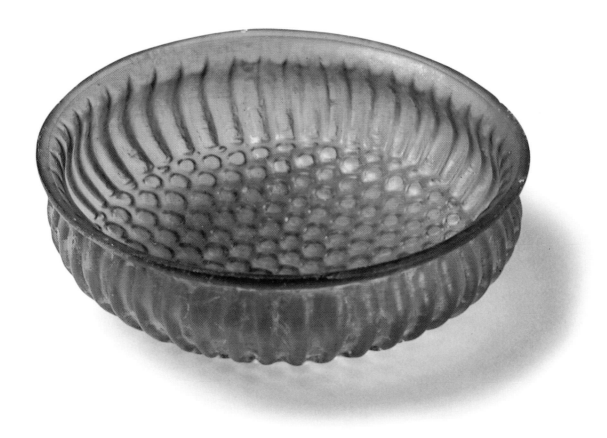

35

Fish flask

Eastern Mediterranean, Syria-Palestine
3rd - 4th century AD
H 7.2cm L 19cm

Free-blown flask in the shape of a fish, made of translucent, yellowish-green glass. The vibrant colour contrasts which would once have been an important part of the visual impact of this delightful flask are now mainly obscured by iridescence in numerous pin-prick pockets over the surface. The fish is designed with an open mouth and a club-form tail. Amethyst glass has been trailed on at the mouth, eyes and tail ending, and an opaque, sealing-wax red at the side fins and the almost comb-like dorsal fin.

This piece is a charming expression of the natural fascination over many centuries on the part of glassmakers living around the Mediterranean with the production of glass fish. The shape of a fish provides all the formal prerequisites of a scent flask: a bulbous body and the mouth or tail to provide the aperture appropriate for the narrow closing. One of the earliest and best known of such fish flasks is the 18th dynasty Egyptian core-formed vessel in opaque glass now in the British Museum which was found in a temple at al-Amarna; it rather resembles this present piece in size and shape (EA 55195, Tait 1991, p. 28, fig. 23). By the Roman period the translucent qualities of glass were being exploited, and while some examples attempted to reproduce scales and fins by means of mould-blowing as the production method (see, for example, Tait 1991, p. 83, fig. 103), applied pincered trails as displayed here allowed for polychrome effects, which satisfied the taste for increased naturalism.

Formerly Kofler-Truniger Collection

Published Lucerne 1981, p. 111, no. 437; Kofler-Truniger 1985, p. 42, lot 66.

Comparative material
For the shape: Isings's Form 95, 'Ungentaria in fancy shapes', Isings 1957, p. 112. Isings comments that the unguent bottles in the shape of fish existed in all parts of the Roman Empire. At the time she was writing, only one such flask, found in a mid-3rd century grave at Cologne, was datable.

36

Snail rhyton

Eastern Mediterranean

1st - 2nd century AD

H 19.5cm D(lip) 11.2cm D(foot) 6cm

Free-blown rhyton in the form of a snail, of pale bluish-green transparent glass, with an applied conical foot and a short, abrupt and strongly cupped rim, possibly intended to carry a lid. An elegant, extended body gives grace to the form, lifted upon its base as if in a drinker's hand. The lower terminal of this superb object represents the head of a snail, with tooled, looped protrusions indicating knob-ended eyes. There is an extended, pointed snout, hollow to the tip, where it has been purposely broken away to allow liquid to be poured from the snout into the drinker's mouth, as is the case with the related example in the Newark Museum (Auth 1976, p. 94).

The surface carries a gentle, vertical arrangement of fine-grained iridescent weathering.

Glass rhyta are rare, and imitate metal prototypes. Their type moved eastwards from the Mediterranean sphere; an example is preserved in Kabul (Hackin 1939, no. 138). The height of this particular rhyton is unusual within its class. A smaller, more robust version with the same lip and probably from the same workshop is now in the Eretz Israel Museum, Tel Aviv ("Recent Important Acquisitions", Journal of Glass Studies, vol. 34, Corning 1992, p. 126, no. 2).

Comparative material
Isings form 73 (Isings 1957, p. 91). Other glass rhyta are in the Newark Museum (Auth 1976, p.94), the Los Angeles County Museum, ex Hans Cohn Collection, where the snail-head is lacking (Saldern 1980, no. 114, pp. 114, 115), as well as Eretz Israel Museum and Kabul examples mentioned above.

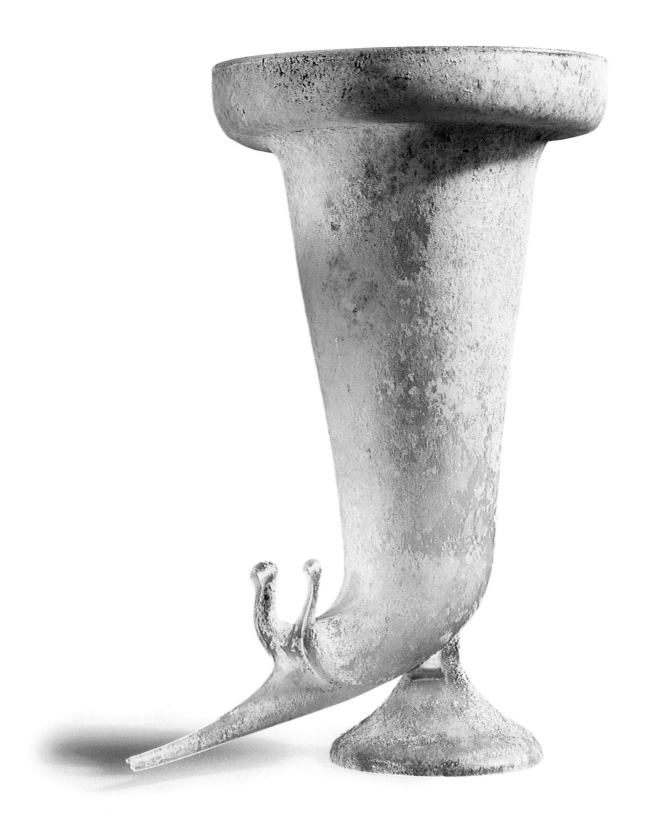

37

Sasanian cut glass bowl

Iran

3rd - 7th century AD

H 7.5cm W 11.3cm D(rim) 10.5cm

Cut glass bowl with circular facets made from a thick colourless glass with a brownish tinge. The piece is a little deeper in form than a true hemisphere and has a slightly constricted rim. The exterior is decorated with four rows of circular concave facets varying between 1.9cm and 2cm in width. There is a large facet some 3cm wide at the very base, which serves to produce a kind of foot-ring if the bowl is stood upright, and the other facets are arranged around this. The glass is bubbly and somewhat corroded, presumably as a result of its burial conditions, so that the surface is rather pitted both inside and out; there is a fine iridescence preserved in the surface hollows in colours of rose-red, apricot and green. Despite the pitting within the facets, however, their edges are still remarkably sharp.

This is a type of Sasanian glassware. Some examples may have been made in the Syria-Palestine region, but the majority have been attributed to the Gilan province of Iran near the Caspian Sea and north of the Elburz mountains. More than a hundred examples were excavated there by Shinji Fukai (Fukai 1977, pp. 35, 36, figs. 20, 21). Fukai believed the type to have been made between the 1st and the 7th centuries; various actual finds of this glass type are dated to the 1st, 3rd, 4th, 5th and 6th centuries. A most beautiful bowl with the same arrangement of facets as the present piece, but without any deterioration caused by burial, can be seen in the Shoso-in Treasure Repository at Nara to which it is believed to have been donated in the 8th century, although it probably arrived in Japan at the same time as the one buried in the tumulus of the emperor Ankan (ruled 531-35 AD). Fukai designated this style of glass the 'Shoso-in type'.

Comparative material
Fukai 1977, pp. 34-39, pls. 1-3, gives a general discussion of the type, which he cites as glass bowl-type 1-A in his classification of glass vessels found at Gilan. Fukai reports that one characteristic common to vessels of this type is that seven smaller facets surround the large central facet at the base. Fukai's pl. 1, a bowl in a private collection in Kyoto, is very similar to the present example. For another such vessel: Lucerne 1981, p. 120, no. 483.

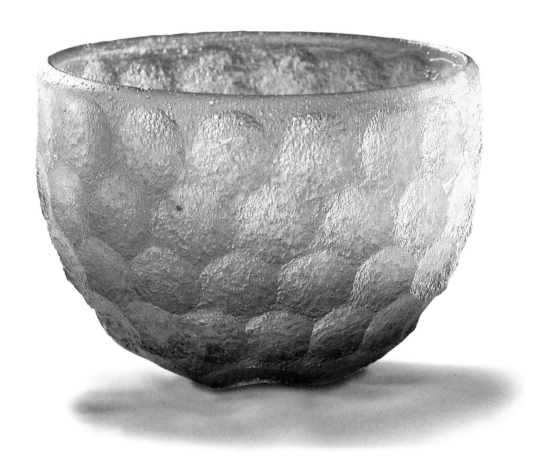

38

Partho - Sasanian bowl

Iran, Gilan province

3rd - 7th century AD

H 7cm D(rim) 11.3cm D(base) 11cm

Low cylindrical bowl of thick grass-green glass, with upright sides, and the remains of a pontil mark flattened on a marver plate on the underside of the base. Both the underside and the wall show evidence of spinning and it appears that the glass was first spun flat – using the same method by which window-glass roundels were made – and was then further spun at right angles to a marver plate to produce the upright side wall.

The design is typical of production in the Partho-Sasanian period in Iran, but the design continued in currency with a wider distribution area into early Islamic times. A completely undecorated Sasanian example, of thick purple glass, is in a private collection in Nagoya, Japan, while three pieces of Persian and Egyptian provenance made from green and greenish-blue glass, with moulded facets in the walls, are in the Victoria and Albert Museum (C.288, 289, 70-1937). Further examples of the shape with thinner walls than any of these have been found at Samarra (Iraq) in 9th-century levels. Another with similarly thin walls in a Swiss private collection is moulded with dots in raspberry-like clusters, a feature which is typical of Egyptian wares in the 8th, 9th and 10th centuries.

Comparative material

Fukai 1977, pl. 17, is the glass at Nagoya; the Victoria and Albert Museum's examples are in Honey 1946, pp. 40-41, pl. 12G, 13E; the example in Switzerland is in Lucerne 1981, p. 132, no. 570.

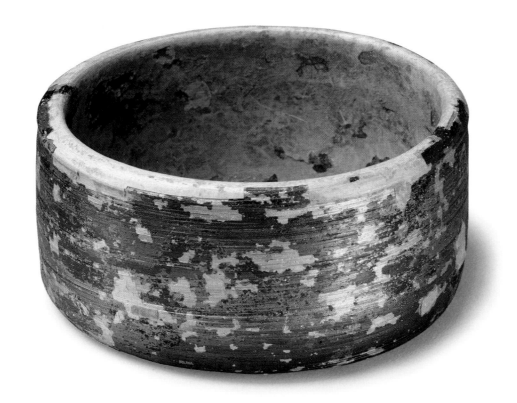

39

Translucent footed bowl

Iran

6th - 9th century AD

H 8.1cm D(rim) 13cm D(base) 6.6cm

Translucent turquoise glass footed bowl, free-blown to a hemispherical form, standing on a conical foot-ring. The wall is angled at around 3cm below the rim, from which point it tapers to the foot-ring. The vessel was marvered flat round the upper wall to produce the angled body which, in combination with a high conical foot, is one of the most popular shapes in the early Islamic period. Both foot and bowl were adroitly manufactured from one gather of glass and a waist was tooled between bowl and foot, while the base-ring was made by pushing the lower portion of the spherical gather inwards against the body of the glass, producing a high kick with the foot-ring left in double-thickness glass.

A remarkable feature of this vessel is the gentle iridescence, which takes the form of pin-prick corrosion all over the surface. This is combined with an irregular film of pearly, apricot-coloured weathering crust, the edges of which are browned, within the interior and the underside of the base. The aesthetic effect of the pale, roseate weathering crust against the translucent turquoise is beautiful in the extreme, as something added by time and chance to the original maker's intentions. A very similar glass material, with similar surface weathering, and a vessel of somewhat related design, can be seen in no. 145 of the Hans Cohn Collection, Los Angeles (Saldern 1981, p. 152, colour pl. 10), a goblet-vase from Iraq or Iran dated to the 5th or 6th century.

This beautiful footed bowl reproduces a vessel shape greatly favoured in 'Abbasid and Samanid times seen both in silver and ceramic wares of the early Islamic period. The shape was longer lasting in ceramic than in silver, and continued in use in parts of northern Iran, at Nishapur, for instance, until the 11th and 12th centuries. Examples in glassware are rare, and difficult to date; the chronology of glassware shapes in the early Islamic period is not particularly well established because of the lack of precisely dated examples. There is little doubt, however, that in Iran the late Sasanian period and the earlier centuries of the Islamic period saw the production of footed vessels in a variety of styles, among them some spectacular pieces in blue, green and purple glass.

Comparative material

For an example of related shape and of similar date – and with the same extraordinary iridescent surface corrosion – in the Hans Cohn Collection, Los Angeles, see Saldern 1981, p. 152, no. 145, colour pl. 10; Sasanian and early Islamic footed bowls in blue, green or purple are illustrated in Saldern 1981, p, 16, p. 184, cat. no. 188, and Fukai 1977, pl. 17a, pl. 19.

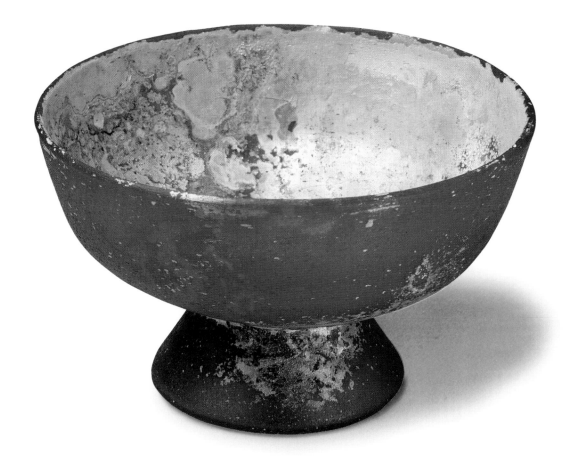

40

Mosaic glass table top

Rome, c.1866

(Ancient glass inlays, Egypt and Rome, 1st centuries BC)

D 76cm

Marble table-top by Giovanni Rossignani, inlaid with Hellenistic and Roman glass from Egypt and Rome of the first centuries BC, made in Rome around 1866. The round mosaic table-top is formed from white mosaic marble set with over 2,000 fragments of plain opaque and mosaic glass of around 330 different designs. The piece was entered by the Pontifical Government in the Paris International Exhibition of 1867.

The basic design is conceived as a sunburst within a ring of stars. The sunburst is centred on a small rectangle of Ptolemaic floral mosaic glass and immediately surrounding this are cool-toned rays in pale and dark blues set out on a red disc, 12.3cm in diameter, within a narrow aureole of radiating strips of glass in rich polychrome tones. From this central motif there extends outwards an arrangement which creates an illusion of overlapping petal shapes, but which is in fact composed of triangles of highly coloured ancient mosaic glass alternating with triangles of (presumably) 19th century opaque glass in hues which graduate from orange to gold to pale yellow. This latter feature enhances the suggestion that the hub of this arrangement is a light source. The triangles, arranged in eight concentric rows, are smallest at the centre and increase in size to the outer edge of the sunburst. The rays these triangles form are not straight, but curve so as to belly out in a clockwise direction.

The sunburst motif is contained at its outer edge by a narrow band of white marble within which is a mosaic band containing sixteen octagons in yellow and red, each of which surrounds a turquoise-coloured eight-pointed star. The octagons are set against a turbulent pattern of onyx mosaic glass in predominant tones of grey-brown and mustard-brown contained between bands of a kind of glass which imitates the green marble known as verde antico. In spite of the unusual colour choices of brown, green, red, yellow and blue, this outer band produces – by intention – the effect of a night sky beyond the outer reaches of the sun.

Comparative material

Two other circular marble table-tops incorporating at least some ancient glass fragments as inlays have recently been seen on the London art market. One was sold at Christie's in June 1987; this was 67.5cm in diameter, and had a composition centred upon a winged classical-style head of somewhat mixed iconography but suggestive of Medusa frontally placed within a clipeus of cobalt blue. The other table-top, some 84cm in diameter, also exhibited the 'crazy pavement' approach to the arrangement of its ancient fragments which is a feature of the piece sold at Christie's, but here, an assemblage of mosaic glass fragments, mainly in colours of lavender, terracotta and blue, was arranged in six crescentic swags descending from bull's-eye swags round the periphery of the central roundel. Grose 1989 gives good parallels for many of the vast number of ancient glass types incorporated; they are too numerous to detail here.

Glass from the Ancient World 89

GLASS FROM THE ISLAMIC WORLD

Raffi Soleimani was among the first in Persia to appreciate the high quality of early Islamic glass which was only beginning to come on to the art market in the period between the two World Wars. Up to that time it was the glass of the Safavid revival that represented the achievement of the Persian glassmakers. Hadji Soleimani has inherited his father's enthusiasm for early Islamic glass. It is not surprising that for the most part he and his father have collected glass vessels found in Persia since these were the first to come to hand, but whenever possible they have also acquired examples of the glass products from other regions of the Islamic world as they have done in their collections of glass from the ancient world.

The Islamic world, at least in its early centuries, was a unitary civilization in which trade flowed freely between the various regions of Dar al-Islam. This is why it is not always possible to determine whether objects found in any one region are imported or indigenous products. This applies particularly to glass in the Islamic period. In the first four centuries of Islam there were four principal centres of the glass industry: Egypt, Syria, Mesopotamia and Persia, each with its own artistic traditions. It has so far not been possible to distinguish between the chemical constituents of the glass from these regions. Moreover, there is little or no difference in techniques. When, however, one type of glass vessel is found in one particular area and nowhere else, we can be fairly safe in assuming that it was made in that area. Of the eleven pieces described below only two seem in the present state of our knowledge to have originated outside Persia (object nos. 44 and 49). It is true that the other nine pieces were executed in techniques that were practised in all four centres, but since they were found in Persia and can be compared with the glass vessels found in controlled archaeological excavations at Nishapur and elsewhere we need have no hesitation in assuming them to have been made in Persia.

As well as inheriting the techniques of their predecessors, the Islamic glassmakers developed new ones. The principal changes, however, were in the types of vessel and the style of decoration. Several of these novel shapes are represented in the Hadji Baba Collection: the small flask or bottle intended probably for precious distillations such as scent, with a spherical body and short neck (object nos. 46, 47); the simple beaker (object no. 41) and the footed and stemmed goblet (object no.45); a larger flask, probably intended for the table, with funnel neck on a bell-shaped body (object no. 50); and another type of vase or flask with a spherical body and tall narrow neck. All these types were current in each of the four glassmaking centres between the 8th and 11th centuries. Just such a new shape, worked in an established technique, is the small flask (object no. 46). The body is carved with rows of hollow-ground facets and the base with a larger facet similar to those on the hemispherical bowls of the Sasanian period. The neck of the vessel is carved with seven plain facets in contrast to the hollow facets on the body.

In the early Islamic period, glassmakers were particularly skilled in relief carving on glass. This craft was a legacy of the Sasanian glassmakers. In order to show the continuity of this tradition we have included here the beautiful footed beaker with relief discs (object no. 45) which can be compared to similar beakers with relief discs found by the Japanese on a Sasanian site in the province of Gilan in northern Persia (Fukai 1968, pls. 19-22 and figs. 25, 26). The only difference is that the discs on the Hadji Baba beaker each have a central relief boss. It is, therefore, of

the Sasanian period and is included here in order to show that relief carving on glass was already an established tradition in Persia. On the small flask (object no. 47) which, because of its shape, is of the early Islamic period, there is also a row of four circular discs carved in low relief, each with a small central boss, as in the Hadji Baba beaker (object no. 45).

A further innovation in the Islamic period was the carving of raised ovals such as those on another flask (object no. 48). The small flask (object no. 49) shows a new treatment of carving in which hollow carved facets on the edge of the shoulder are combined with deeply grooved roundels on the body so that the raised edges of the grooves give the impression of relief.

Another technique requiring the use of the wheel was incised decoration. A fine example is the flask (object no. 50). The shape was probably developed in Persia from where it was introduced into the glass houses of Syria and Egypt. The incised pattern on the flask is typical of the 'Abbasid style of decoration which was current in Persia and Mesopotamia in the 9th and 10th centuries.

Carved and incised glass vessels were time-consuming and costly to produce. There were other techniques that were less demanding of time. An easy method and one that seems to have been unique to Islamic glassmakers was that of tonging. One of the faces of the metal tong, engraved with the pattern, was impressed onto the surface of the glass while still hot and malleable. The tong could best be applied to the side of an open vessel such as a bowl or beaker. If an impression of the pattern was needed on both sides of the glass, a tong was used in which the engraving on the one face was positive and on the other

negative, as on the beaker object no. 41. The patterns were necessarily narrow since a broad tong face would have distorted the curving surface of the glass.

One of the commonest forms of decoration was that of moulding. The usual procedure was to blow the paraison into one or more moulds of wood, pottery or bronze. Such was the technique used in the two long-necked vases object nos. 32 and 43.

The glass industry in Persia flourished from the 7th to the 11th centuries but thereafter declined. Persia seems to have had no share in the production of the gilded and enamelled glass for which the glass houses of Syria and Egypt were famous in the 'Ayyubid and Mamluk period (1171-1517). The revival of the Persian glass industry was due to Shah 'Abbas the Great (AD 1587-1628/AH 985-1038). He brought to his capital city of Isfahan Venetian glassmakers from Murano who taught the lost art to the Persians. The industry flourished and according to the French jeweller and traveller Jean Chardin the best glass was produced in Shiraz. Characteristic was the use of coloured glass - cobalt blue was much favoured - and novel forms such as the sprinklers with flower-shaped mouths and ewers with delicate handles and curving spouts. The fine long-necked sprinkler (gulābzan) (object no. 51) has a mouth in the form of a flower bud and the body is moulded with successive rows of jewel-like elements as though from a necklace. This fine example may have been made in Shiraz in the 18th or 19th century. The industry has continued into recent times and the same high standard has been maintained as can be seen in the flower vase of blue glass (object no. 52) with elaborate moulded decoration of a naturalistically rendered nasturtium plant.

41

Sasanian footed glass cup

Persia
6th - 7th century AD
H 8.6cm D(rim) 10cm D(foot) 4.4cm

Footed cut glass cup. Colourless glass. Everted rim, straight side which curves into pad base. Carved in relief with two rows of discs, nine in the upper and eight in the lower, each slightly concave and with a raised central boss. The lower row is carved on the inward curve to the foot and the discs are placed beneath the interspaces of the discs in the upper row. The edge of the foot is slightly angled and a grooved inner circle is carved on the base.

Private collection

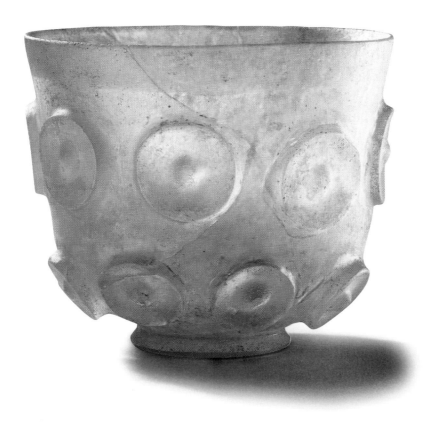

42

Pincered beaker

Persia

9th century AD

H 9cm D(rim) 8.5 D(base) 5cm

Colourless glass beaker with very slight yellowish tinge. Rounded lip, straight side descending slightly inwards to flat base, pincered decoration in relief on exterior wall and in negative on interior wall. The decoration consists of a half circle at the rim to which is attached a pendant in the form of a lozenge within a larger one, and below, three leaf shapes, each of the two outer ones with a raised pearl, all framed within paired vertical lines running from lip to base. This composition is repeated three times. Intact with fractures and iridescent patches. Pincering is a technique of decoration used on open vessels such as beakers and bowls. Here a double tong was used; the two faces, the one positive and the other negative, were hinged together. The composition suggests a necklace. The leaf-shaped figure with pearl is rare but occurs in relief-cut glasses (Folsach 1990, fig. 233).

Comparative material

The more usual form of beaker, widely current in Persia, Mesopotamia, Syria and Egypt in the 9th and 10th centuries, has a vertical side. The beaker with side sloping inwards to base is less common. For glasses with pincered decoration from Iran, see Lamm 1935, pl. 29A-C and Gladiss and Kröger 1984, fig. 110.

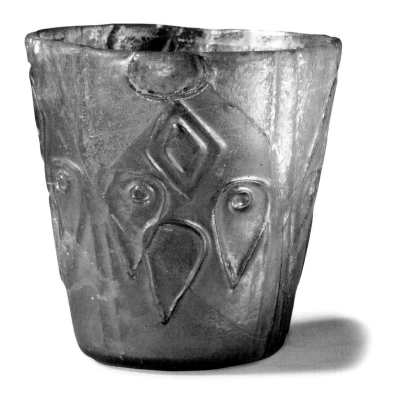

43

Blue Sprinkler

Persia

9th - 10th century AD

H 22.5cm

Sprinkler (*gulabdān*) of blue glass. Long cylindrical neck on spherical body with foot-ring. Moulded decoration: on shoulder, indeterminate decoration with raised defining line; on body, four roundels each containing a standing peacock facing to right and left alternately. Between these roundels are what appear to be vases of baluster form.

Comparative material

The form has been found in Iran, Syria and Egypt commonly with moulded decoration often arranged, as here, in interwoven roundels (Lamm 1929-30, 12: 20). The peacock was a long established motif in the Near East and is found on a pressed medallion of Syrian origin in the 5th-6th century AD (Lamm 1929-30, 15: 9).

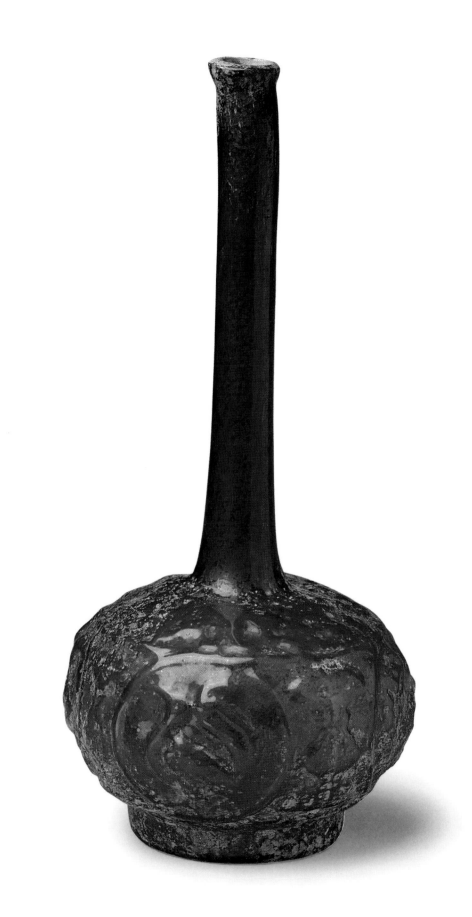

44

Sprinkler

Persia

9th - 10th century AD

H 28.5cm

Sprinkler (*gulabdān*) of cobalt blue glass; long, slightly tapering cylindrical neck, horizontal and slightly concave shoulder from which the side slopes outwards and then sharply inwards to indented base with remains of pontil break, thick blue thread wound spirally around base of neck; on body, moulded decoration of reticulations in each of which is a tear drop. Large patches of greyish weathering.

Comparative material

The usual form of sprinkler current in Persia in the 9th and 10th century AD has an added foot-ring and narrow cylindrical neck such as object no. 42 and other examples have wheel-cut decoration (Glass 1991, fig. 144, left). Those without an added base, such as this, are rarer. For another example, see Lamm 1929-30, 14: 3, where the moulded decoration consists of 'goose eyes'.

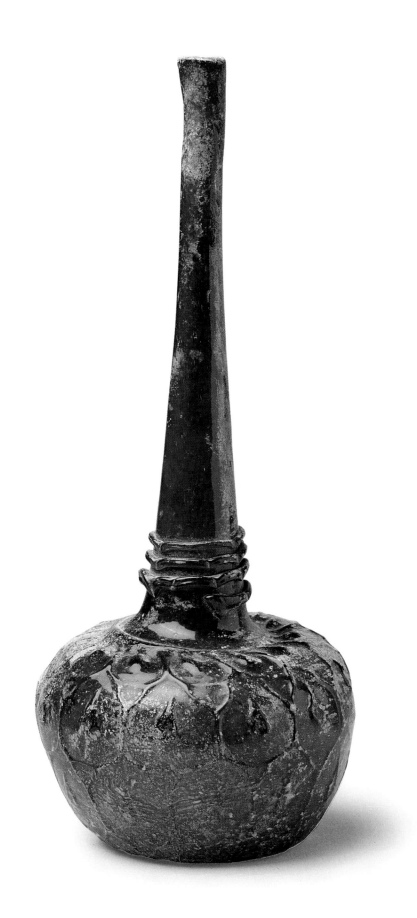

45

Two-coloured bottle

Egypt

9th - 10th century AD

H 9cm

Bottle made in two parts, the neck and shoulder of colourless and the body of light blue glass; body with moulded decoration consisting of a row of raised ovals each with a central raised boss; neck slightly funnel-shaped on sloping shoulder from which side curves gently inwards to pad foot with remains of pontil break. Patches of creamy white weathering and remains of iridescence.

Comparative material
David Collection 1975, p. 19, a jug of blue and colourless glass with moulded decoration, Iran 8th-9th century. In the Benaki Museum there is a mould-decorated glass of similar form but with narrower neck; the upper half of the body is green and the lower half colourless with a greenish tinge (Clairmont 1977, pl. XIV, no. 231).

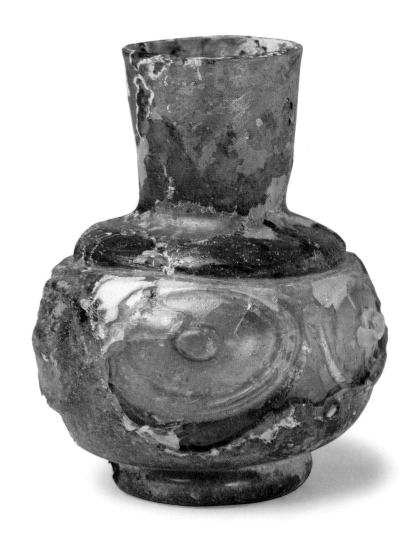

46

Cut glass flask

Persia

9th - 10th century AD

H 6.8cm

Cut glass flask. Colourless glass with pale yellowish-green tinge; short neck and spherical body on low pad base. Neck carved with seven facets, two concentric grooved bands around shoulder, and on body three rows of hollow carved alveole facets joined tangentially. Base carved with shallow concavity.

Comparative material

There is a flask of similar shape but taller (H 10.8cm) in the Museum für Islamische Kunst, Berlin (Gladiss and Kröger 1984, no. 188); it has eight facets on the neck and three rows of oval hollow facets on the body.

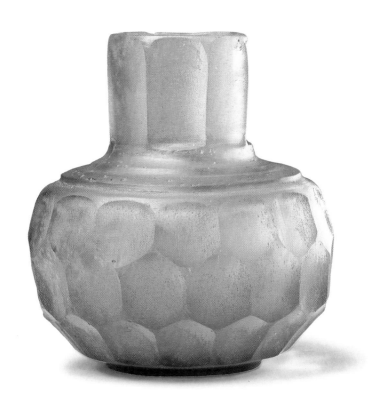

47

Carved flask

Persia

9th - 10th century AD

H 7.2cm D(base) 5.8cm

Flask of colourless glass, free-blown and then carved. Low neck carved with seven facets, slightly tapering shoulder, straight sided body carved with six vertical facets, each separated from the other by grooved lines; on each body facet an oval carved in relief; base flat with slight concavity. Patches of greyish white weathering on which are traces of iridescence. Damage to one of the neck facets.

Comparative material

For a fragmentary glass of similar decoration, see Lamm 1929-30, 54: 2. The wall fragment of another vessel of this type was found in the Jawsaq Palace, Samarra (Lamm 1928, p. 74, Abb. 46, nr. 222). For an example found in Iran, see Lamm 1935, pl. 7G, 32E..

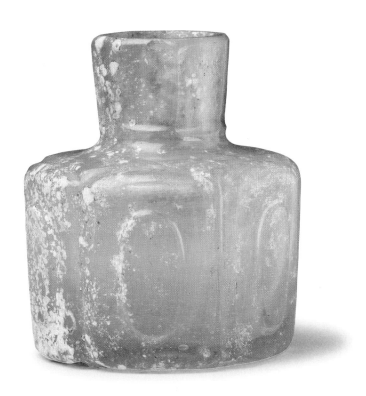

48

Carved flask

Persia

9th - 10th century AD

H 9.3cm

Flask of transparent glass with very pale blue tinge. Neck slightly funnel-shaped with six facets, globular body, flat base. Carved on the body with four circles each with a raised central boss, between vertical grooved lines. Grooved lines on shoulder form a square when seen from above. Patches of pale cream weathering.

Comparative material

The circles follow the curve of the body; this is not the case with other examples from Iran (Lamm 1935, pl. 31, F-J). Faceted circular discs with raised roundels in the centre are found in Byzantine glasses of the 7th-8th century AD.

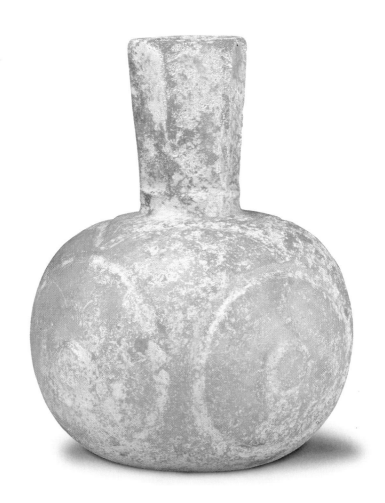

49

Cut glass bottle

Persia

9th - 10th century AD

H 8.7cm

Cut glass bottle, colourless with slight yellowish tinge. Neck slightly funnel-shaped, horizontal shoulder, straight side sloping very slightly inwards to flat base. Carved decoration: on neck below lip a grooved line, then an undulating grooved line with a raised disc within each of the six undulations. Three concentric grooves on shoulder, on the outer edge of which is a frieze of hollow ovals joined tangentially. On the side six raised discs each with a central boss, and another grooved line forming a swag beneath the lower half of each of the discs. On base concentric grooved lines. Intact, the surface is matt owing to burial. The sunken portions are covered with a light whitish weathering and patches of iridescence.

This is a fine example of the manner in which hollow ground facets could be elaborated for decorative effect. As in object no. 46, the circular section of the vessel has been retained and in this detail it can also be compared with a bell-shaped flask found in Kirmanshah and now in the Museum für Islamische Kunst, Berlin (Gladiss and Kröger 1984, no. 207).

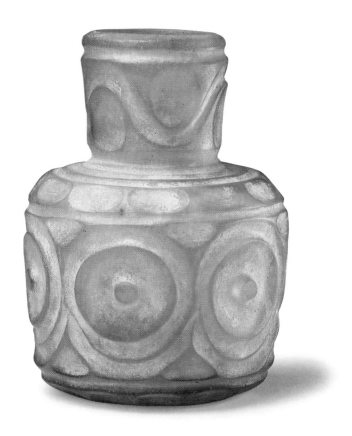

50

Wheel-cut flask

Persia

10th century AD

H 16cm

Flask of transparent cobalt blue glass; funnel neck on bell-shaped body. Wheel-cut decoration: on neck between grooved lines paired rhomboid facets and below five vertical facets; on shoulder paired concentric grooves and then, on edge of shoulder, a band of crosses suggesting a guilloche between grooved framing lines. On the main face of the body, a repeat composition of a pine cone within a diamond, flanked by pine cones attached to a double garlanded stem running around and below the composition; these pine cones are set each beneath a gable which in turn is flanked by a cruciform arrangement of volutes. Base of flask is flat with traces of a pontil break. Patches of pale brown weathering.

Comparative material

A long-necked flask, found in Sultanabad (Arak), Persia, and now in the British Museum, is carved with an abbreviated version of the pattern on the Hadji Baba flask (Masterpieces 1968, fig. 143). For other and similar versions see Lamm 1929-30, 58: 16, and a bottle of greenish glass with a frieze of Xs on the shoulder (Glass Studies, X, 1968, p. 184, no. 23).

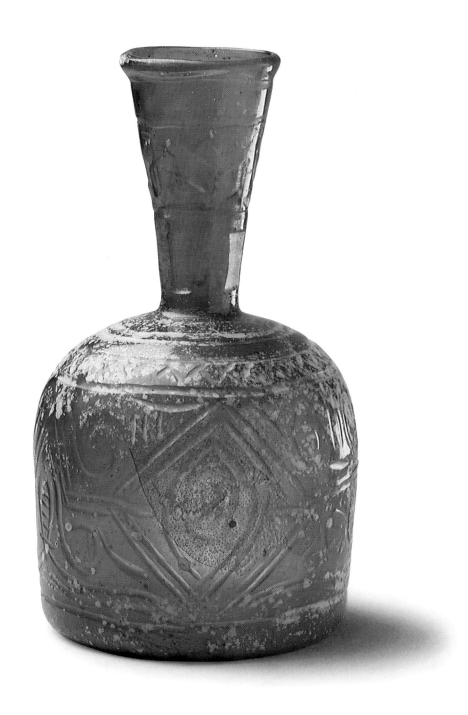

51

Blue Sprinkler

Persia

18th - 19th century AD

H 25cm

Sprinkler *(gulābdan)* of transparent blue glass. Long neck, slightly tapering, with 'bud' mouth; pear-shaped body moulded in relief from shoulder downward with a row of short vertical ribs and a raised roundel below each pair, then a row of buds each standing on a pearl which is mounted on a segmental base; finally, the tips of the leaves of the rosette which forms the decoration of the base. Prominent pontil fracture on base.

Comparative material

This is a typical example of Persian glass after the revival of the industry in the 17th century in Isfahan and Shiraz. There are many similar examples of this shape and style of decoration such as a vase formerly in the Godman Collection and now in the British Museum (SPA, pl. 1451 A, C); see also Gluck 1977, p. 102, the vase on right.

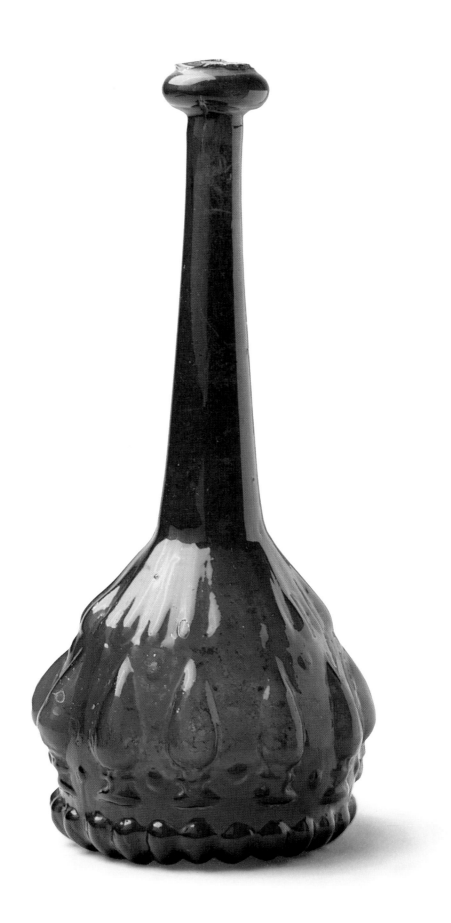

52

Moulded vase

Persia

19th - 20th century AD

H 25.8cm D(rim) 12.5cm

Vase of transparent blue glass. Trumpet mouth on pear-shaped body; added foot-ring; relief decoration consists of a plant, possibly a poppy, curling upwards spirally from the base. Three faint vertical seams just visible on the body indicate that the decoration was obtained by blowing into several moulds, but the incised details on the flowers and leaves were probably completed by tooling.

Comparative material

The technique of moulding flowers and leaves was practised by the glassmakers of Persia in the Safavid revival and later (for later examples, see Gluck 1977, p. 105, lower and p. 107).

ISLAMIC POTTERY

The pottery items in this catalogue, although they are relatively few in number, are representative of fourteen hundred years of development in this area of Islamic art. With six exceptions, all come from Iran. This by no means implies a preference on the part of Hadji Soleimani, or of collectors, for Persian pottery. What it does indicate is the debt owed by Islamic pottery as a whole to the great tradition of Persian pottery and to the art of its makers. Here again we must enter a caveat. The potter's art did not originate in ancient Persia: the making of faience and the technique of glazing were known in ancient Egypt as early as the late fifth or early fourth millennium BC. The ware known as 'Egyptian faience', with its beautiful turquoise blue alkaline glaze, dates back to pre-Pharaonic times, but its spread was rapid and by the third millennium BC glazed faience ware including tiles was being made in Crete, Syria, Mesopotamia - and Persia.

The earliest evidence for Persian glazed faience is from the second millennium BC. Vessels and tilework have been excavated in the south-west, most notably at Susa and Choga Zanbil, and Ziwiye and Hasanlu in the north-west yielded a ware that was polished but not glazed. Alkaline-glazed faience wares continued to be made in Egypt until the Roman period when they were replaced by two kinds of fine ware: an unglazed polished red ware known as *terra sigillata* or Samian ware and the lead-glazed ware found throughout the Roman Empire. In Persia, however, the manufacture of alkaline-glazed faience continued until the advent of Islam at the beginning of the 7th century AD.

One of the most popular and best known types of pottery vessel from the Sasanian period from the 3rd to 7th centuries AD was a large jar of bulbous form sometimes with three small handles on the shoulder and decorated with an appliqué design. This decoration consists either of serpents coiling round the upper part of the vessel or arcades of 'rope' or 'cable' lines with further cable decoration between and below the arches of the arcade. These jars were covered with green or turquoise alkaline glaze. It was formerly thought that the green glaze was lead-based, but recent tests in Japan have shown that there is no lead content. Examples of this 'Sasano-Islamic' or 'blue-green ware' are known from excavations at Ctesiphon, Susa and Siraf and have been dated to the period from the 6th to 9th centuries. The examples from Susa and Siraf are in fact Islamic and date from the 8th or the 9th century. The specimen in the Hadji Baba Collection object no.53 is bulbous and tapers towards its base. Jars of this kind were partly sunk into the floors of houses and were used for storing liquids.

Another type of early Islamic glazed pottery is the 'tin-glazed' ware produced in imitation of imported Chinese porcelain and white stoneware. The potters, unable to make porcelain, covered the body of their vessels with an opaque tin glaze and thus produced an elegant white ware of their own. The earliest pieces are plain white bowls, small cups and jars without any surface decoration. Subsequently, decoration painted in cobalt blue, manganese purple or green was added and was usually of a simple kind - a tree or a rosette on the base inside but more frequently a pseudo-*kufic* inscription. On many examples these inscriptions are purely decorative and have no meaning, probably because the decorator was illiterate and imitating inscriptions he could not read, but this style of decoration shows that the tremendous aesthetic potential of Arabic script had been recognised. The colour favoured in Iraq was cobalt blue, the Persian potters preferring manganese purple, which they often combined with splashes of green. The 'tin-glazed' bowl object no.54 is decorated with a pseudo-*kufic* inscription and with splashes of green and it is a typical and very beautiful example of this kind of ware. Recent tests carried out on examples of 'tin-glazed' ware have shown that the glaze is not invariably tin and that in many cases lead was used. This is probably because the potters discovered that a lead glaze fired at low temperature which kept the particles in suspension produced the desired thin opaque white layer over the body of the vessel. It is not known which glaze has been used on object no.54.

One of the problems encountered by early Islamic potters was the tendency of painted decoration to run during firing and this undoubtedly accounts for the absence of elaborate design on these vessels. The potters of Central Asia and north-east Iran re-introduced a technique which largely overcame this difficulty by covering the surface with clay slip, a technique known since prehistoric times, and adding clay to the pigments. This prevented the colours from running during firing. The vessels were then coated with a transparent lead glaze with a greenish tinge caused by the presence of copper. This technique of 'slip painting' offered numerous decorative possibilities.

Afrasiyab, a suburb of Samarqand, and Nishapur were the two major centres for the production of slip-painted ware, but it was also made in many other areas, e.g. Jurjan (Gurgan), in Kirman province and Afghanistan. Among the most interesting categories of slip-painted ware is 'Nishapur polychrome' or 'buff ware'. Made only in Nishapur, its elaborate decoration consists of animal and human figures painted in yellow and green and outlined in manganese purple as well as floral designs. An interesting example of this group is object no.55, decorated with a galloping horse and above it another animal figure, possibly representing a lion. This design is evidence for the survival of Sasanian motifs; there are a number of Sasanian silver-gilt plates decorated with a mounted huntsman attacked from behind by a lion. These are the Sasanid 'hunting' plates recalled in the present example with the huntsman omitted. Another type of polychrome ware with floral decoration over a cream slip is represented by the magnificent dish no. 56. Some examples of this category of ware include pseudo-*kufic* inscriptions in the decoration. Both object nos. 55 and 56 may be attributed to Nishapur and dated to between the 9th and early 11th century.

There are two more examples of slip-painted wares in the collection, object nos. 57 and 58. The former is an example of 'black-on-white' ware which had manganese purple decoration, usually inscriptions, painted in a white ground. Another version of the technique is exemplified by object no. 58; the whole of the vessel is covered on both sides with a manganese ground slip and the decoration overpainted in white which has a greenish tinge from the copper in the lead glaze.

An entirely different technique is illustrated by object nos. 59, 60 and 61. Known as *sgraffiato*, this involved the incising of the decoration in the ground slip and adding splashes of green, yellow and occasionally manganese, the whole covered with a colourless, transparent lead glaze. A good example of an early version of this technique is provided by object no. 59. Wares of this category were made in Iran and Iraq as early as the late 10th century. Our bowl may have come from north-east Iran, possibly from Nishapur, and may be dated to the 11th-12th century. A special type of *sgraffiato* ware, known as 'Aghkand', was made in north-west Iran, Syria and Anatolia during the 12th century and is characterised by green, yellow and manganese decoration separated by grooved or incised lines. Syrian wares display in addition champlevé or carved decoration. The decoration of typical 'Aghkand' ware represents animals or birds against foliage, but Syrian examples were mainly decorated with geometrical, floral and vegetal patterns; only rarely were humans or animal figures present.

An example of the latter ware is object no.60, its provenance clear from its paste, shape and decoration. The third piece of *sgraffiato* ware, object no. 61, is from Afghanistan as is clear from its shape, design and from its decorative technique in particular.

The collection contains two remarkable and rare specimens of unglazed ware, object nos. 62 and 63. The former is sphero-conical and bears the signature of its maker, 'Umar. Vessels of this type are known under several different names deriving from the function attributed to them; these include 'hand-grenade' suggesting a somewhat unlikely function,

'aelopile' on the hypothesis that they were used to increase the temperature of kilns which is equally improbable because most of these vessels have elaborate decoration and some are glazed. It is most likely, as was once suggested by the late Professor Richard Ettinghausen, that they were used for storing some precious liquid such as mercury. This theory would seem to be borne out by tests revealing traces of mercury which were carried out on one such vessel in the collection of the School of Oriental and African Studies at the University of London. A unique piece is object no. 63, a master-mould for making pottery vessels; no similar moulds are known.

By the middle of the 11th century AD a new body material had been introduced into the repertoire of Islamic pottery. This was a composite white frit paste approaching in its whiteness and fineness the quality of Chinese porcelain and on which could be applied the alkaline glaze which offered new decorative possibilities. This ware is known as 'Saljuq fine'. Among sub-divisions of the category is a ware made mainly in Iran and Syria known as 'Saljuq white', of which the main characteristic is a colourless, transparent glaze. The collection contains two examples: object no. 64 from Iran and object no. 65 from Syria. Other types of 'Saljuq fine' were coated with a coloured monochrome alkaline glaze as is the case with the pouring vessel object no. 66 and the unusual model of a caravanserai object no. 68, which may have been a toy.

Another variant of 'Saljuq fine' ware is painted black, cobalt blue and turquoise under a glaze which may be either clear and colourless or coloured. It was made in Iran, Iraq, Syria and Afghanistan. The example in this collection, object no. 69, comes from Afghanistan and is particularly notable because the white paste of the vessel is painted in red in those areas not covered by the glaze. The beautifully moulded surface of object no. 70 together with the black and cobalt underglaze decoration including an inscription wishing its owner well, make it an outstanding example of its type.

Lustre painting was practised in Egypt and Mesopotamia from the 9th to the 11th centuries, but it reached its apogee in Iran between the late 12th and early 14th centuries when the potters of Kashan, many of whom were renowned during this period, produced vessels and tiles in monumental or miniature styles richly decorated with meticulous care. Lustre wares of this period are represented in this catalogue by eight examples: two bowls object nos. 71, 72, a pouring vessel object no. 73, a bottle object no. 74, a figurine of a camel object no. 75, a small jug object no. 76, a fragment of a large dish object no. 77 and a frieze of four tiles from a much longer inscription object no. 78.

The ultimate achievement in the decoration of 'Saljuq fine' ware was the application of the paint over the glaze. The Persian terms for this kind of ware are mīnā'ī (enamelled) and haftrangī (seven coloured). The latter is the more appropriate term because as many as seven colours were used on a single vessel. The decoration seems to have been inspired by miniature painting and illuminated books; some vessels bear scenes from the Shāhnāma and other court scenes. A different, but not rare, design of overall floral and arabesque motifs decorates object no. 79. This type of overglaze painting would appear to have emerged during the last quarter of the 12th century and disappeared soon after the Mongol invasion of AD 1219-20/ AH 616. It was replaced towards the end of the 13th century by a new kind of overglaze decoration known as lājvardīna in which the ground was covered entirely with cobalt blue glaze over which the decoration was painted in red, white and, occasionally, black with further embellishment in gold leaf. During a period of transition between the decline of the mīnā'ī technique and the emergence of lājvardīna, vessels were decorated in polychrome over a turquoise blue glaze and the gold was painted on rather than fixed with adhesive. The star-shaped tile decorated with a dragon, object no. 80, would seem to belong to this transition period.

Typical of the Mongol (Ilkhanid) period in Iran was a version of the underglaze-painted ware known as

'Sultanabad' of which there are three sub-categories, two of them represented in this catalogue by small bowls object nos. 81 and 82. Although the precise provenance of these examples is not known, shape, decoration and general quality in the case of the former indicate Kashan. The latter object no. 82 is entirely different as far as shape, decorative style and colour are concerned; it is, however, more characteristic as an example of 'Sultanabad' ware. A definite Syrian influence would seem to indicate a provenance from a pottery in north-west Iran which was, with Tabriz as its capital, the centre of Ilkhanid power. This type is also known to have been copied in the province of Kirman in the south-east, but the quality is considerably inferior.

The large jar, object no. 83, is a rare example of Timurid monochrome glazed pottery. It is a plain, functional vessel which must have been used for storing liquids in everyday use, such as oil or water. The lead glaze covering it reveals immediately that it is a vessel posterior to the Mongol period and thermoluminescence tests bear this out.

With the rise of the Safavid dynasty (AD 1501-1732/AH 907-1144), Islamic pottery entered into a new golden age after nearly two centuries of decline. One of the most striking and interesting types of Safavid pottery is the blue and white ware. The technique of underglaze blue was known and used in the 13th century, but it was from the 16th century onwards that it played a more significant role. Most of this later blue and white ware imitated Chinese porcelain and was exported to western Europe at a time when internal troubles in China had caused a drastic decline in the manufacture of blue and white porcelain. Indeed this was the principal reason for Persian potters' production of this ware, which, although faience, faithfully reproduced Chinese decoration including landscapes, figures and Buddhist symbols. The large plate object no. 84 is one example and was most probably made in Mashhad which, with Kirman and Yazd, was one of the three centres of production. The second example object no. 85 is not Chinese in the style of its decoration, which is reminiscent of 'Kirman polychrome' ware.

Kirman was also famous for its monochrome glazed pottery usually green, yellow or celadon, with a simple floral or scroll design scratched in the glaze or painted over it in white, pink or blue. Other examples, however, have elaborate moulded decoration in relief which sometimes depicts quite elaborate scenes. The *qaliyān* (water-pipe), object no. 86, is a Kirman monochrome glazed vessel of this type and has floral decoration in low relief.

Among the most typical Safavid wares is that known as 'Gombroon'. Gombroon (modern Bandar 'Abbas in the Persian Gulf) was never a pottery producing centre, but it was, and still is, an important harbour from which these wares were exported to Europe and East Africa, hence the name given to the ware on the basis of the large number of examples found on the site. It is, in fact, a late version of 'Saljuq white' ware made of very fine white faience which was coated with a transparent glaze with a strong greenish tinge. Often plain, it was the elegance of shape and the fine white colour almost matching that of porcelain that gave Gombroon ware its beauty. Other varieties were painted in cobalt blue or black under the glaze and in some cases had open-work designs in addition. Two vessels of this kind are represented in the collection by bowls object nos. 87 and 88.

The last item in this section of the catalogue is the plate object no. 89 produced in the famous kilns of Iznik in north-west Anatolia. Iznik was producing pottery long before it began to make the beautiful faience vessels and tiles from the late 15th century onwards. Iznik wares reached their apogee when sealing-wax red was added to the palette at some point in the mid-16th century. The decoration of this plate is in the form of a bouquet of flowers rising out of foliage, a motif that recent research has shown to have become typical during the reign of Sultan Murad III (AD 1574-1595/AH 982-1003), to which period this example can be dated.

53

Jar

Iraq or Persia

8th - early 9th century AD

H 51cm D(top) 16cm D(base) 14cm

Large jar, 'Sasano-Islamic' or 'blue-green' ware. Yellow earthenware, green glaze with appliqué decoration on its upper part. Bulbous upper body tapering towards the base with short neck and flat everted rim, standing on a low foot-ring, with three small handles on the shoulder. It was probably formed from two separate parts. The upper part of the body is decorated with appliqué cable lines forming three arches with further lines below and between the arches.

Private collection

Comparative material

Sarre 1925, p. 25, pl.VI/1-2; Koechlin 1928, p. 52, pl. 8; SPA 1938-9, pls. 189A, B-109A, B, these latter two are the closest examples to our jar; Ettinghausen 1939, p. 674; Lane 1947, pl. 3; Wilkinson 1963, pl. 17; Whitehouse 1968, p. 14, pl. VIc; idem 1972, pl. Xb; Rosen-Ayalon 1974, pl. X/a, c-d; Charleston 1979, pl. 1. For the most extensive study on these jars, see Fukai 1981, p. 40 and ff., pls. 107-108.

54

Splash-decorated bowl

Persia, probably Nishapur

9th - 10th century AD

H 7.5cm D 25cm

Bowl, 'tin-glazed ware'. White glazed buff earthenware, rounded sides and everted rim, on a shallow flat and grooved base. The white glaze could be tin or, more probably, a low-fired lead glaze.

The vessel is decorated inside with six green splashes on the rim with a seventh at the centre. A pseudo-*kufic* inscription painted in manganese purple runs down from a point on the rim towards the base.

Comparative material

Wilkinson 1972, Group 6, nos. 10-19.

55

Nishapur polychrome dish

Persia, Nishapur

10th - early 11th century AD

H 6.5cm D 23cm

Dish, slip-painted, 'buff' or 'Nishapur polychrome' ware. Buff earthenware, straight radiating walls, vertical rim and everted lip, on a shallow foot-ring with a concave base.

The vessel is covered with a creamy ground slip and the decoration, painted in yellow, green and manganese purple, represents a galloping horse with a smaller animal, probably a lion, above. This may recall the scene on Sasanian silver-gilt 'hunting' plates. Semi-palmettes and floral patterns fill the areas between. The inside of the rim carries repetitive pseudo-*kufic* motifs with small green and yellow patches above them. On the exterior the rim is decorated with ovals alternately coloured yellow and green outlined in manganese purple and separated by manganese vertical lines. The whole of the vessel is covered with a colourless transparent lead glaze.

Comparative material

A very similar vessel was illustrated and discussed by Lacam 1960, p. 157; Mikami 1964, colour pl.3.

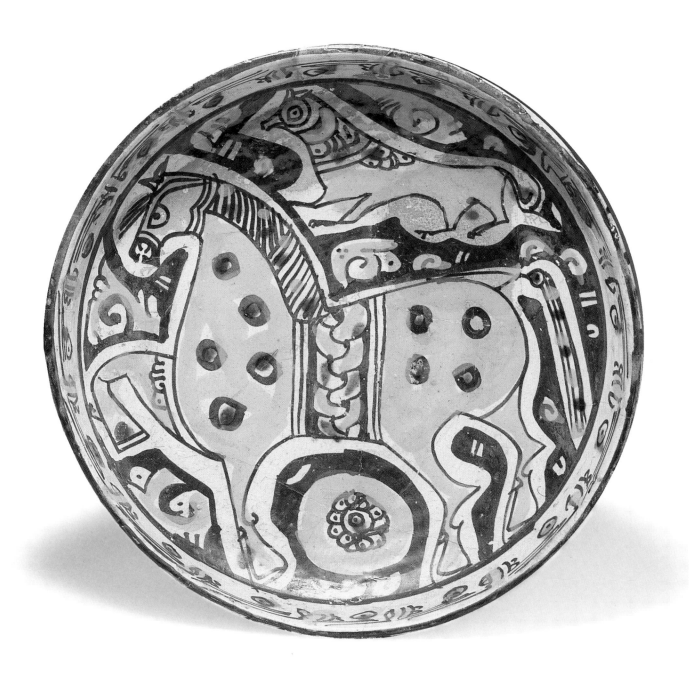

56

Nishapur polychrome dish

Persia, Nishapur,
9th - 10th century AD
H 4.8cm D 34.4cm

Large slip painted, 'buff-ware' or 'Nishapur polychrome' shallow dish, footless, decorated in dark brown with streaks of yellow and green. The superbly painted central picture depicts a seated couple, the bearded male holding a bottle and with outstretched arm offering a flower to his long-haired female companion. She holds a stringed instrument in one hand and a cup in the other.
Both wear geometrically-decorated clothes, and a variety of objects surround them including two pairs of boots, a pair of scissors, a comb, a fish, birds and foliate sprigs suggesting a garden and a pond, perhaps.

There is a *kufic* inscription at the right-hand side of the male figure, and the vertical sides of the dish are decorated on the interior with a band of foliated *kufic* broken by quatrefoil rosettes. The exterior sides are painted with stripes and ropework bands.

Comparative material
Wilkinson, p.47, no. 64 for a fragmentary dish depicting a related male figure in a chevron-decorated garment and also holding a cup.

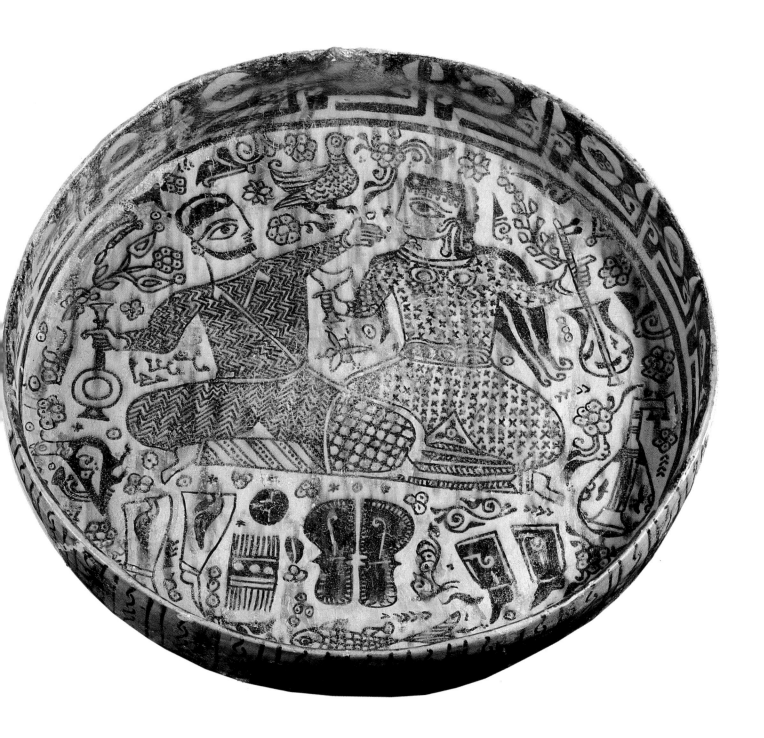

57

Slip-painted bowl

Persia, Nishapur

10th - early 11th century AD

H 7.5cm D 25.5cm

Bowl, slip-painted, 'black on white' ware. Buff earthenware with rounded sides and slightly everted rim on a raised foot.

Both sides of the vessel are coated with a creamy white ground-slip. The interior of the vessel is decorated with a manganese purple cursive inscription round the walls with a tiny manganese painted four-petalled flower in the centre of the base. The entire vessel is covered with a transparent and colourless lead glaze which has a yellowish-green tinge.

The inscription reads:

'[True] generosity is not a rich man dispensing his excess, but charity from one who himself is poor. With good fortune, and A [. . .]'

Comparative material
Lane 1947, pl. 14/B; Wilkinson 1972, Group 3, nos. 25-30, 32-35.

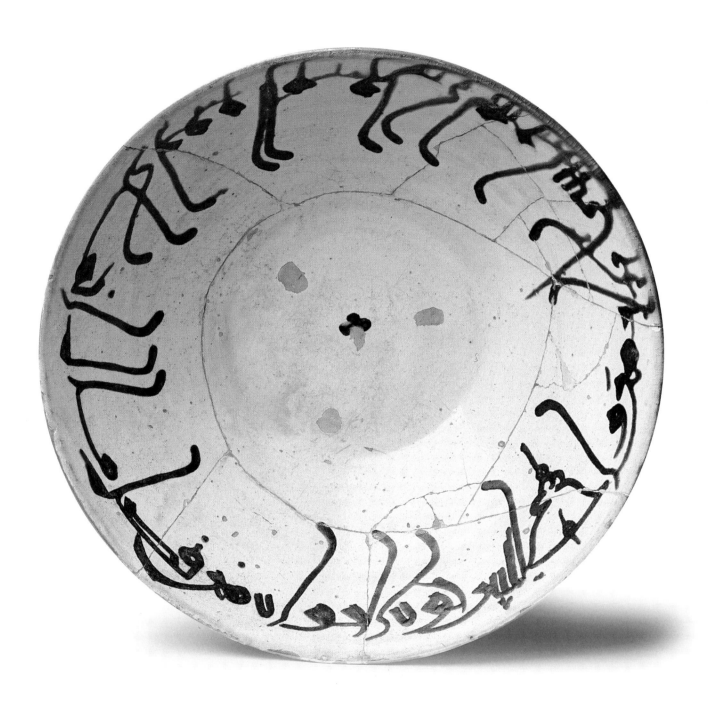

58

Slip-painted bowl

Persia, probably Nishapur

10th - early 11th century AD

H 8cm D 24cm

Bowl, slip-painted, 'coloured engobe' ware. Buff earthenware, with rounded sides and everted rim, on a raised flat base.

The vessel is entirely covered on both sides by a manganese purple ground-slip on which the decoration was painted in white, then coated with a transparent and colourless lead glaze which nevertheless gives a pronounced greenish colour to the white design. The decoration represents a large and stylized bird within a circle. In the remaining areas are panels, dots and eyes in white. A series of festoons with tiny dots decorates the rim.

On the outside are four groups of slanting lines of different length with simple stylized flowers between them.

Comparative material
SPA 1938-9, pl. 563A; Ishiguro 1986, pl. 6. For an almost identical vessel cf. Folsach 1990, no. 71, and for a different example, no. 73.

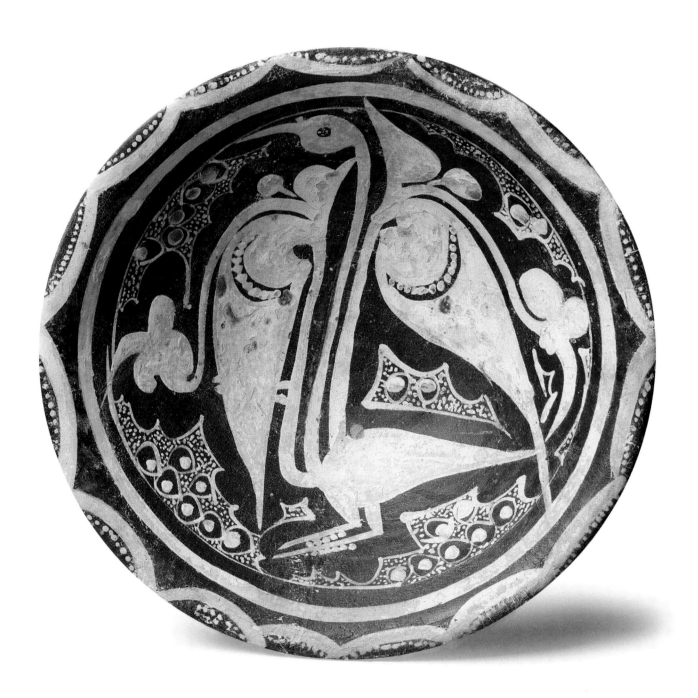

59

Splashed sgraffiato bowl

Persia

11th - 12th century AD

H 9cm D 25cm

Bowl, splashed *sgraffiato* ware. Buff earthenware with straight radiating sides and slightly everted rim, on a raised flat base.

The vessel is entirely covered on both sides with a white ground-slip into which the decoration was incised. The design consists of three large ovals which radiate from a circle outlining the base. There is a vertical spiral band in the middle of each oval. The areas between the ovals are filled with simplified three-lobed arches, each containing three manganese dots, while the spandrels are filled with simple scrollwork. Splashes of yellow and green complete the decoration, over which is a transparent and colourless lead glaze.

Comparative material

Mikami 1964, colour pl. 1; Wilkinson 1972, Group 2, nos. 19, 31, 40-47, 65; Kiani 1978, pl. 74.

60

Sgraffiato bowl

Syria

12th - 13th century AD

H 11cm D 31cm

Large bowl, *sgraffiato* of the 'Aghkand' type. Red earthenware with rounded lower and vertical walls and everted flat rim on a heavy foot-ring.

The vessel is coated with a brownish-red ground-slip into which the decoration was incised and then painted in green, manganese purple and yellowish-brown colours. The design consists of a large four-petalled flower which divides two wide green concentric circles into four. The petals of the flower are outlined in green and inside are painted alternately in manganese and brownish-yellow. Simple scrollwork fills the areas between the arms of the petals within the first green circle, and between the two circles is a band of large roundels. The vertical part of the wall carries a band of slanting lines framed by manganese borders. The rim is decorated with a series of triangles which are alternately painted in green and brownish-yellow with manganese dots between them.

Comparative material

A similar, but smaller, plate is in a private collection in Paris and was excavated in Istanbul. It is attributed to the Byzantine period, 12th-13th century. Cf. Soustiel 1985, pl.17.

61

Sgraffiato bowl

Afghanistan, probably Bamiyan

12th - early 13th century AD

H 8cm D 17.5cm

Small bowl, *sgraffiato* ware. Red earthenware, rounded sides, upper part vertical with everted sloping rim, on a raised slightly concave base. The vessel is covered on both sides with a white ground-slip which reaches half-way down on the exterior.

The decoration is restricted to the interior and the design is incised into the ground-slip revealing the dark body of the vessel, while some areas are painted in green. On the base is a stylized flower within double circles. The surface of the cavetto is divided into four by V-shaped patterns. Inside each of these four areas there is a large half-palmette against a background of slanting lines. The surface between these four fields has scale patterns dotted in manganese. Splashes of manganese decorate the everted rim.

Comparative material

For a similar sgraffiato bowl from Afghanistan, cf. Gardin 1957, pls.I-III; for a closely related example, cf. Folsach 1990. no. 81.

62

Moulded sphero-conical vessel

Iraq or Persia

12th - 13th century AD

H 13cm W (centre) 8cm

Sphero-conical vessel, unglazed white earthenware with moulded decoration. The lower part is hexagonal, the upper part circular with a dome-shaped element on top, capped by a globular short neck which has a small circular opening. The upper part of the vessel is decorated with four lines of small bosses and almond shapes, the latter in the top and bottom lines. A fifth line of almond shapes decorates the dome-shaped part. On the lower part, each side of the hexagon carries a rhomboid, outlined by a thin incised line and at the corners on top are punch-dotted circles. On one side the signature of the artist is given within a small rectangle, which reads: *'amala 'Umar* ('made by 'Umar').

Comparative material

Lane 1947, pl. 36/F, a green glaze example from Raqqa, 12th-13th century; Fehérvári 1973, no. X.8, p. 116, pl. 62b. For the possible function of these vessels, cf. Seyrig 1959, Dumarcay 1965, Ettinghausen 1965, Albaum 1969 and Rogers 1970.

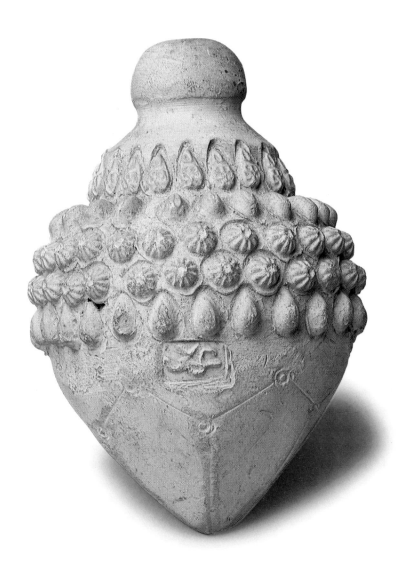

63

Pottery master-mould

Probably Persia

12th - 13th century AD

H 15.5cm D (top end) 7cm D (lower end)
5.5cm

Master-mould for a pottery vessel. Solid white
earthenware. With an overall carved 'negative'
decoration, this was used for copying several
different types of 'positive' moulds. A pear-shaped
object, flat at both ends one of which is narrower
than the other. The wider end has a small plug which
most likely served for the release of oxygen from the
inside during firing. The decoration on the flat
surface of both ends consists of different types of
rosette which could have been used as moulds for
the bases of vessels. The decoration of the sides is
divided into four horizontal registers of which the
outer two carry petals of different sizes. One of the
other two registers consists of a band of five large
roundels formed by an intertwined scroll which also
serves as a border. The roundels depict pairs of
confronted or opposed animals and birds: sphinxes,
senmurvs, eagles and lions.

Comparative material

*Some excavated mould fragments from Nishapur have
been published and illustrated in Wilkinson 1972, Group
11, nos. 57-68.*

64

Saljuq white pitcher

Persia

12th - 13th century AD

H 29cm D (base) 7cm

Pitcher, *'Saljuq* white' ware. Composite white frit paste, bulbous body, tall tapering neck ending in a cup-shaped mouth with a pointed spout, on a splayed foot-ring. Originally it had a handle, which is now missing. On the neck below the mouth is a series of tiny bosses in two rows. The entire vessel is covered with a colourless alkaline glaze with a greenish tinge. Some areas of the surface are covered with iridescence.

Comparative material
Mikami 1962, colour pl. 9.

65

Saljuq white vase

Syria

12th - 13th century AD

H 23cm D (top) 6.5cm D (base) 7.5cm

Vase, *'Saljuq* white' ware, composite white frit paste.
Pear-shaped body with a short cylindrical neck and
everted lip on a splayed concave base. With the
exception of the inside of the base and on one side
above it where the glaze is manganese purple, the
vessel is decorated with a colourless alkaline glaze
which has a greenish tinge. There are large areas
covered with heavy iridescence.

66

Turquoise pouring vessel

Persia

12th - 13th century AD

H 12cm D (top) 8.5cm D (base) 8.5cm

Pouring vessel, monochrome glazed ware. Composite white frit paste, bulbous body with short neck, on a low foot-ring. Two rampant lions which serve as handles are attached at opposite sides to the body and neck. There are also two short bent spouts, again at opposite sides. The entire vessel, except the base, is covered with a turquoise glaze.

Comparative material

For a lustre-painted version, cf. no. 74. An identically shaped vessel but with overglaze painting and gilded relief was in the Sir Ernest Debenham Collection, cf. SPA 1938-9, pl. 678A; Mikami 1966, pl. 25. For an overglaze-painted and gilt version, cf. Folsach 1990, no. 115.

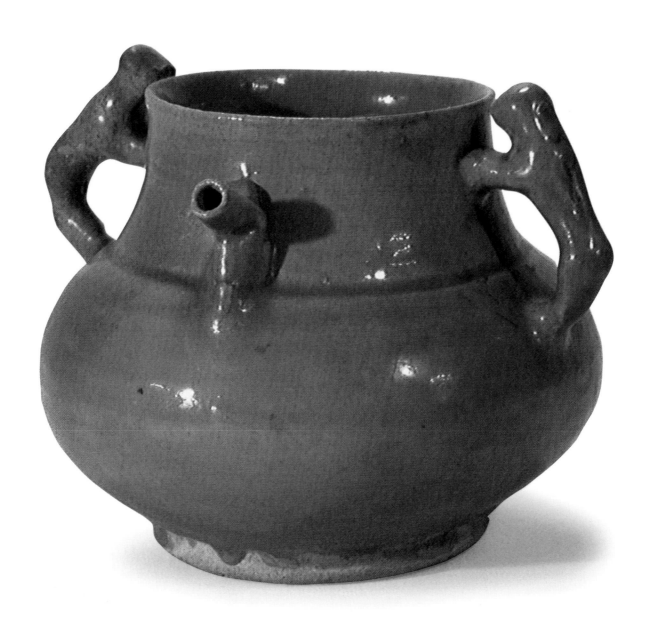

67

Turquoise vase

Persia

12th - 13th century AD

H 13cm D (top) 8.5cm D (base) 9cm

Vase, monochrome glazed ware. Composite white
frit paste, bulbous body narrowing towards the top
with a wide opening. The entire vessel is covered
with an alkaline turquoise glaze which stops above
the foot-ring.

The upper part of the body is decorated with a wide
band carrying openwork and moulded decoration.
The openings are filled by the transparent blue glaze.
The moulded design is a floral scroll.

Comparative material
For a similarly closed vessel decorated with lattice - and
scrollwork, cf Mikami 1962, colour pl. 10.

68

Model of a Caravanserai

Persia

12th - 13th century AD

23cm x 16.9cm

Monochrome glazed ware. Composite white frit paste, covered by an alkaline turquoise glaze which stops short of the base. A rectangular object imitating the shape of an Iranian caravanserai with an opening in front which probably represents a gateway flanked by a pair of pilasters. The remainder of the sides is made up of circles. Crenellations run all around the top with stylized animal heads imitating the tops of buttresses at regular intervals. The top of the object shows a number of standing animals, probably horses. A square central area with a circular hole probably represents the courtyard of the caravanserai.

Private collection

Comparative material
SPA 1938-9, pl. 742B.

69

Underglaze-painted jug

Afghanistan

12th - 13th century AD

H 19cm D(top) 8.5cm D(base) 7.5cm

Jug, underglaze-painted ware. Bulbous body, tall
wide opening neck, wide handle surmounted by a
small boss, on a tall foot-ring. Composite white frit
paste coated with a dark red ground-slip on which
the decoration was painted before the glaze was
added. There are four black stripes and black
splashes on either side of the handle under the
alkaline turquoise glaze. Further black splashes
appear on the handle and on both sides of the neck.

70

Moulded underglaze-painted jug

Persia, Kashan

First half of the 13th century AD

H 18cm D(top) 11cm D(base) 9cm

Jug, underglaze-painted ware. White composite frit, globular body with overall moulded decoration, short vertical tapering neck, with small handle, on low foot-ring. The moulded decoration of palmettes and flowers is painted in cobalt blue and outlined in black. The palmettes and flowers are arranged in three horizontal zones running round the body. In the central zone are hanging palmettes and connecting leaf patterns from which split-palmettes depend, interspersed with flowers forming the lower zone. In the upper zone are similar motifs. There is a heavy black line on top of the body and a black register on the neck with Arabic *thuluth* inscription in white, reading:

'May the Creator of the world protect
The owner of this [jug] wherever he may be.
Glory and long life and joy
May not be free from you.
May the speech not be . . .
So that whoever hears it says that it is beautiful.'

There is another inscription on the handle:

'May the Creator of the world protect
The owner of this [jug] wherever he may be.'

A third inscription on the base, also reserved in white on a black ground, reads:

'May the Creator of the world protect
The owner of this [jug] wherever he may be.'
[repeated]
'Glory and long life and joy
May not be free from you.'

At the base are a flower painted in black and a potter's mark: 'umila.

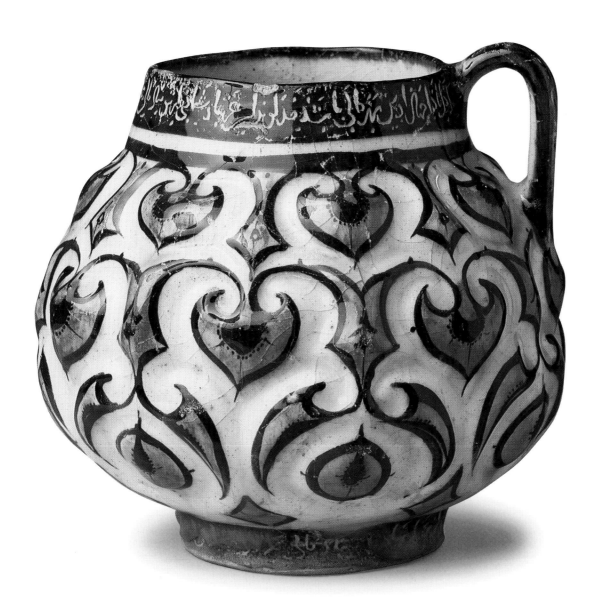

71

Lustre-painted bowl

Persia, Kashan or Jurjan
dated AD 1261-62/ AH 660
H 9cm D 20cm

Bowl, lustre-painted ware. Composite white frit paste with lustre-painted decoration. Rounded sides, slightly everted lip, on a foot-ring. Inside there is a round medallion depicting a hyena in a landscape. In the foreground is a pool with three fish under a stylized sky. A cursive inscription in five parts in lustre on a white ground runs round the cavetto. The rim bears a pseudo-*kufic* inscription reserved in white on a lustre ground which is also decorated with fine scrollwork reserved in white.

Professor Takuo Kato collection, Japan

Comparative material
A close example is illustrated in Bahrami 1949, pl. LIII. There is a similar bowl in the Victoria and Albert Museum, signed by Muhammad ibn Muhammad al-Nishapuri, acc. no. C.162-1977, cf. Watson 1985, colour pl.G; also illustrated in Bahrami 1949, pl. XLIX.

72

Lustre-and cobalt blue-painted bowl

Persia, Kashan or Jurjan

13th century AD

H 8cm D 22cm

Bowl, lustre-and cobalt blue-painted ware. Composite white frit paste, rounded walls with slightly everted rim, on a low foot-ring. The decoration of the interior in lustre and cobalt blue consists of six radiating rectangular panels, outlined in cobalt blue which form a hexagonal star where they meet in the centre. Each panel has a cursive inscription, in lustre on white ground. The areas between the panels are filled with arabesques on a ground of scrolling. The rim carries a pseudo-cursive inscription reserved in white on a lustre ground.

Comparative material
Fehérvári and Safadi 1981, no. 113, pp. 178-79.

73

Lustre-painted pouring vessel

Persia, Kashan or Jurjan

13th century AD

H 13cm

Lion-handled, double-spouted pouring vessel, lustre-painted ware. Composite white frit paste. Almost identical in shape to object no. 66. The decoration in brownish-gold lustre consists of three concentric bands running round the body.

Two of these are narrow, one round the almost vertical rim, the second one on the lower part of the body; the third covers the greater part of the body and is decorated with galloping horsemen separated by cypress trees. The band on the rim bears a pseudo-*kufic* inscription and scrollwork while the lower has scrollwork and floral designs. The two lion-shaped handles and the two spouts are painted in lustre. A pseudo-*kufic* inscription runs round the inside of the rim.

Private collection

Comparative material
Bahrami 1949, pl. XLVII/a. There are two similar lustre-painted vessels in the Ades Family Collection. These are provided with one strap handle only and have no spout, but their decoration is almost identical to that on this vessel; cf. Ades 1976, nos. 73-74. For other examples cf. object no. 66.

74

Lustre-painted bottle

Persia, Kashan or Jurjan
13th century AD
H 20.3cm

Bottle, lustre-painted ware. Composite white frit, bulbous body, with tall and tapering tubular neck and cup-shaped mouth, on a low foot-ring. The upper part of the body is decorated with a wide band enclosing four lobed medallions containing floral designs; between the medallions are arabesques and scrolls. The lower part of the body is covered with scrollwork, while the top has a narrow band of cursive inscription. There is a pseudo-*kufic* inscription on the lower part of the neck, surmounted by more scrollwork on the upper part.

Comparative material
There is an almost identical bottle in the Ades Family Collection; cf. Ades 1976, no. 45. For other lustre-painted bottles in the same collection cf. nos. 41-44, 46-48. Grube 1976, nos. 164-165.

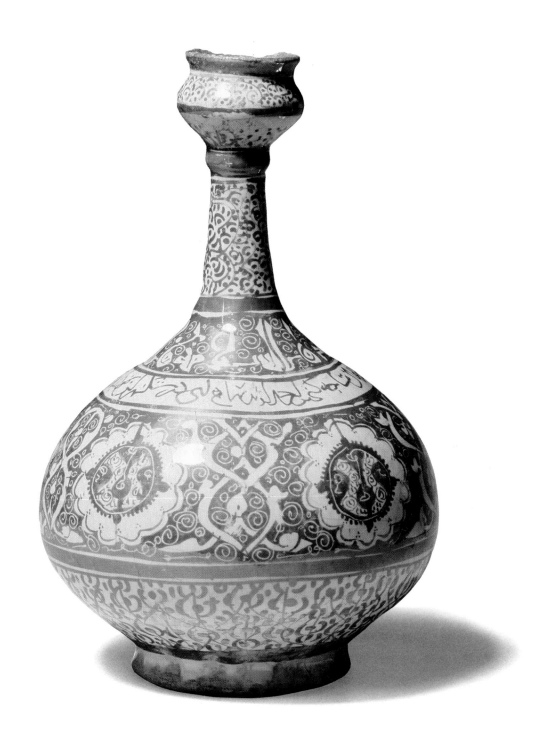

75

Lustre-painted Camel Figurine

Persia, Kashan or Jurjan

13th century AD

H 17cm L 17cm

Camel figurine, lustre-painted ware. Composite white frit, a standing camel on a rectangular base. The entire body, neck, head and legs of the animal are decorated with simple scrollwork, leaves, circles, dots and heavy lines, in brownish lustre.

Private collection

Comparative material
For comparative material and a full discussion of such pottery figurines, cf. Grube 1976, pp. 239-45.

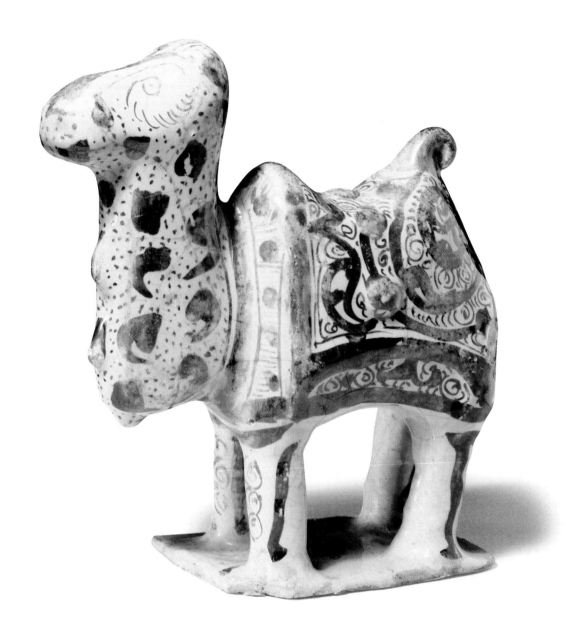

76

Lustre-painted jar

Persia, Kashan or Jurjan

13th century AD

H 11cm D 5cm D(base) 4cm

Small jar, lustre-painted ware. Composite white frit, bulbous body, tall cylindrical neck, on a splayed foot-ring, strap handle with a tiny boss at its top. The body is decorated in two horizontal registers: the lower one bears a pseudo-cursive inscription reserved in white on a lustre ground; a similar band is on the upper part of the neck. The second and upper register is filled with eight stylized birds, probably ducks, above simple scrollwork. The handle is painted in lustre.

77

Lustre-painted fragment

Persia, Kashan

Early 13th century AD

38.2cm x 29.5cm

Fragment, lustre-painted ware. Base, side and rim fragment of a large dish of composite white frit. The decoration is reserved over a brownish lustre-painted ground and the details are also in lustre. On the left is the face of a female figure, wearing a large decorated head-dress. Above this head the rays of a human-faced sun are visible. To the right are scrollwork, part of a *kufic* inscription and a narrow band filled with pearls.

See Fukai, catalogue, 1982. no, 1-37

Photograph by Kazuyuki Yazawa

78

Lustre and cobalt blue-painted tiles

Persia

Late 13th century or 14th century AD

W 94.5cm H 12cm

Four rectangular earthenware sections with moulded, lustre- and cobalt blue-painted decoration, part of a much longer frieze. The inscriptions are in high relief and are painted in cobalt blue and outlined in lustre on a continuous band of scrollwork and leaves reserved in white on a lustre ground. Inscriptions in Arabic:

'Ibn Muhammad Bazlī [?]
[. . .] the weak servant [of God]
Ibn Abū Fawz bā'

79

Mīnā'ī bowl

Persia, probably Kashan

Early 13th century AD

H 8.5cm D 22cm

Bowl, overglaze-painted, mīnā'ī ware. Composite white frit paste, rounded sides, slightly everted lip, on a foot-ring. Covered with a colourless alkaline glaze over which the decoration is painted in red and green and outlined in black. The black is painted under the glaze. The decoration depicts a central rosette surrounded by an overall design of arabesques and knots at the base with a serrated design on the rim. On the exterior a pseudo-cursive inscription runs below the rim.

Private collection

Comparative material
SPA 1938-9, pls. 697A, 694B, 696B; Lane 1947, pl. 73A; Mikami 1964, pl.159; similar decoration appears on a lustre and cobalt blue-painted bowl which was in the J 0 Matossian Collection, cf. Bahrami 1949, LXXVII; a similarly decorated bowl over a turquoise blue glaze is in the Freer Gallery, cf. Atil 1973, pl. 43, also illustrated in SPA 1938-9, pl. 697B; a similarly decorated vessel is in the Ashmolean Museum (formerly in the Barlow Collection), acc. no. 1956-45, cf. Fehérvári 1973, no. 125, p. 102, pl. 54a; Another similarly decorated lustre bowl is in the Ades Family Collection, cf. Watson 1985, pl. 43/A.

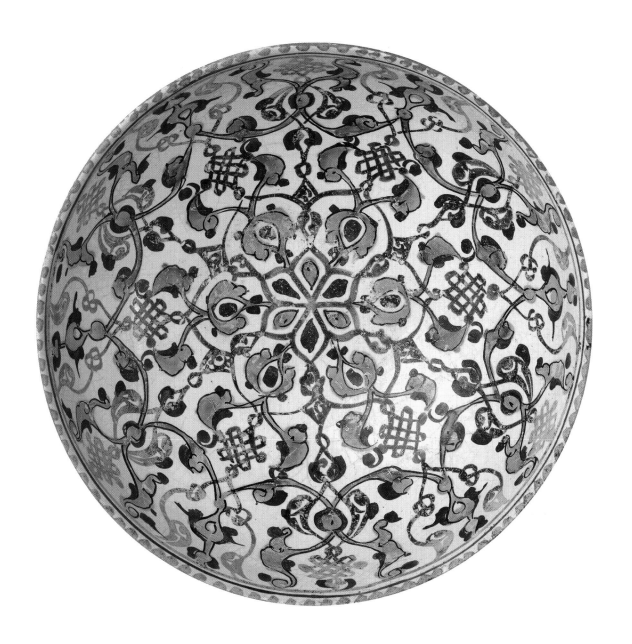

80

Mīnā'ī overglaze-painted tile

Persia

Second half of the 13th century AD

21cm x 21cm

Tile, overglaze-painted, mīnā'ī ware. Star-shaped buff earthenware, moulded and decorated with red and gold painted decoration of a dragon over a turquoise glaze. The surrounding areas show cloud and vegetal patterns, also painted in gold and with outline in red.

Comparative material

A lustre-painted tile with almost identical decoration is in the Keir Collection, cf. Grube 1976, no. 192, ill. p. 253; a hexagonal lājvardīna tile decorated with a dragon is also in the same collection, cf. Grube 1976, no. 196, ill. p. 255; Ishiguro 1986, pl. 38.

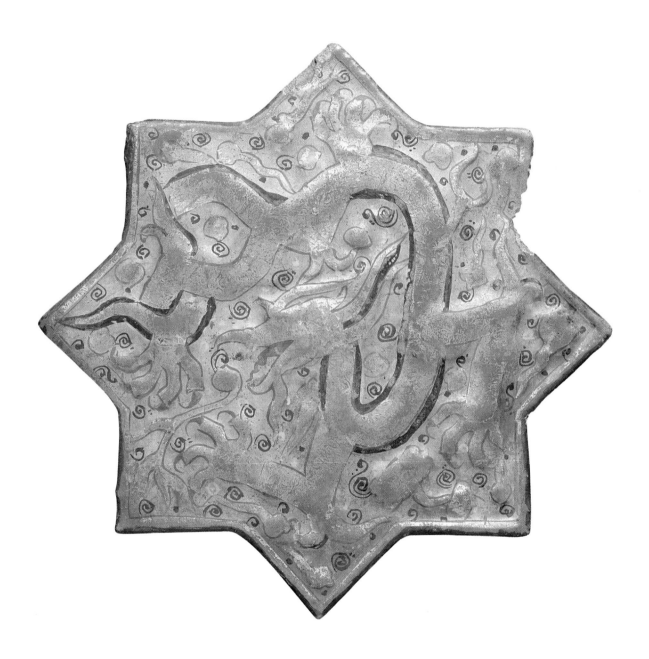

81

Sultanabad bowl

Persia

Late 13th or early 14th century AD

H 6cm D 15cm

Small bowl, underglaze-painted, 'Sultanabad' ware.
Composite white frit paste, rounded sides, short
vertical rim, on a low cylindrical foot-ring. The
decoration is moulded and painted in blue, black and
turquoise under a clear glaze. On the inside is a
large four-petalled flower surrounded by leaves in a
narrow register round the rim. The exterior has a
band with black slanting lines and blue dots
bordered by heavy black lines running round it.

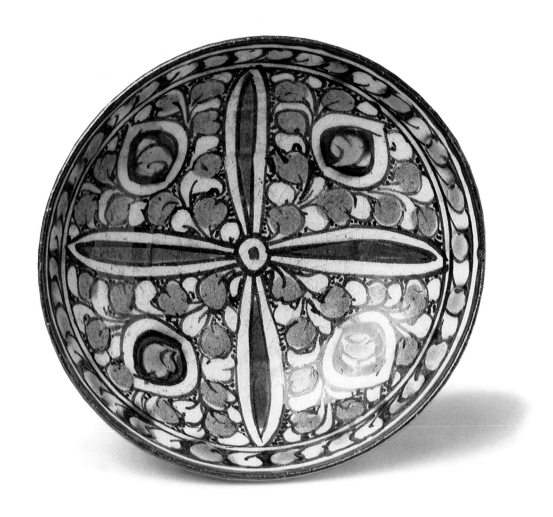

82

Sultanabad bowl

Persia

Late 13th - early 14th century AD

H 8cm D 16cm

Small bowl, underglaze-painted, 'Sultanabad' ware. Buff paste, straight flaring sides, vertical rim with everted and inverted flat lip, on a short, heavy foot-ring. The decoration is part moulded and part painted in black or reserved in white on a grey ground. On the inside are two overlapping kidney-shaped patterns with white circles and tiny black dots inside them and in the surrounding areas. A series of white dots decorates the flat lip. The outside is decorated with white stripes, vertical on the lower part, horizontal on the upper.

Comparative material

Mikami 1964, pl. 186.

83

Large monochrome jar

Persia, Timurid or early Safavid period

Late 15th - early 16th century AD

H 127cm D(top) 40cm D(base) 28cm

Large jar, monochrome glazed ware. Buff
earthenware, coated with a green lead glaze. Pear-
shaped body, tall cylindrical neck with wide and
rolled lip. It bears no decoration except for the
concentric lines which are traces of the potter's
wheel. The vessel was formed from four separate
parts: the base, the lower part of the body, the
upper part with shoulder and the neck. This jar was
examined at the Laboratory for Archaeology and the
History of Art, Oxford. Thermoluminescence tests
indicated that it was fired 435-635 years ago.

84

Safavid blue and white plate

Persia, probably Mashhad

17th century AD

H 7.8cm D 39.8cm

Large plate, blue and white ware. Composite white frit paste painted in two shades of blue under a transparent glaze. Shallow rounded sides, everted sloping rim, on low foot-ring. On the inside the decoration at the base consists of a large circular field depicting a cylindrical object, probably the books tied with a fillet that are one of the Eight Treasures *(ba bao)* of Buddhist lore and a common motif on Chinese blue and white porcelain, surrounded by robes and two tassels. Six radiating panels on the cavetto and the rim are decorated alternately with the same Buddhist emblem as on the base and with Chinese landscapes. The narrow vertical areas between these medallions have wickerwork and floral patterns. The outside is decorated with floral scrolls and simple four-petalled flowers within blue borders. Three pseudo-Chinese 'tassel marks' appear on the base within the foot-ring.

Comparative material
Lane 1956, pl. 78/B; Fehérvári 1976b, no. 156, p. 274, ill. p. 291; Hermitage 1990, no. 102.

85

Safavid blue and white plate

Persia, probably Kirman

17th century AD

H 10cm D 49cm

Large plate, blue and white ware. Composite white frit with moulded decoration, covered with a transparent colourless glaze over decoration in cobalt blue, low horizontal rim and convex ribbed cavetto, sloping everted rim, on a low foot-ring. The painted decoration follows the outline of the moulded design of a large octagonal star. The arms of the star are filled with scale pattern with large leaves in the areas between. The painted decoration consists of a central octagonal star to which eight lobed pendants are attached. The centre of the star and the pendants are filled with floral sprays and floral scrolls decorate the sloping rim. The outside of the vessel is coated with a cobalt blue glaze. A pseudo-Chinese 'tassel mark' is on the base.

Private collection

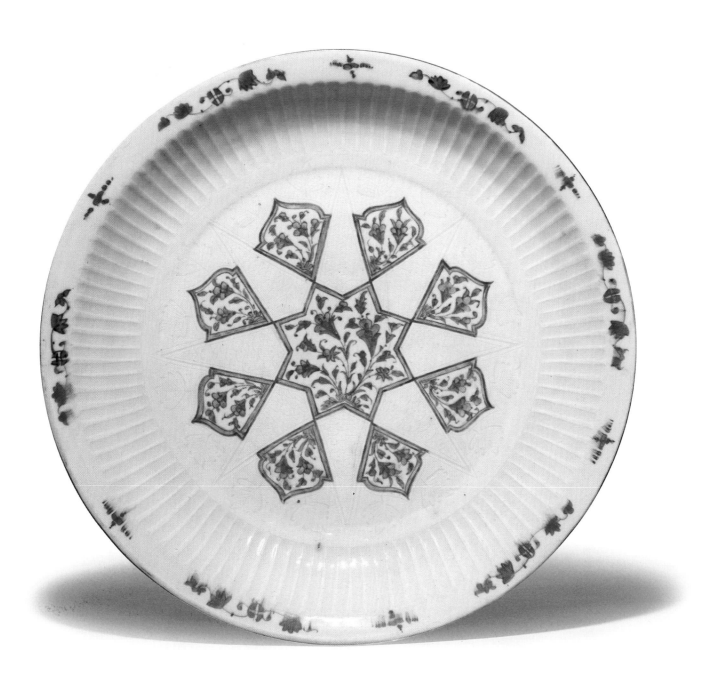

86

Moulded water-pipe

Persia, Kirman

17th century AD

H 20cm D(top) 7cm D(base) 9.7cm

Water-pipe *(qaliyān)*, monochrome-glazed ware with moulded decoration covered with a green lead glaze. Buff earthenware with a bulbous body, raised shoulder, dome-shaped spout with a small raised opening of which part is missing, tall cylindrical neck slightly wider at its top with everted and rolled rim, on a low splayed foot-ring. The body is surrounded with a floral scroll in relief below the spout. A vertical line in low relief running from below the spout to the foot-ring separates the two ends of the scroll. The edge of the shoulder has a number of six-petalled semi-rosettes. Rosettes and scrolls decorate the lower and upper parts of the spout.

Comparative material

For a qaliyān of similar type, cf. Wilkinson 1963, pl. 89; it is coated with a blue glaze with white and ochre decoration, made in Kirman in AD 1658-9/AH 1069; Jenkins 1983, p. 112; Hermitage 1990, no. 105.

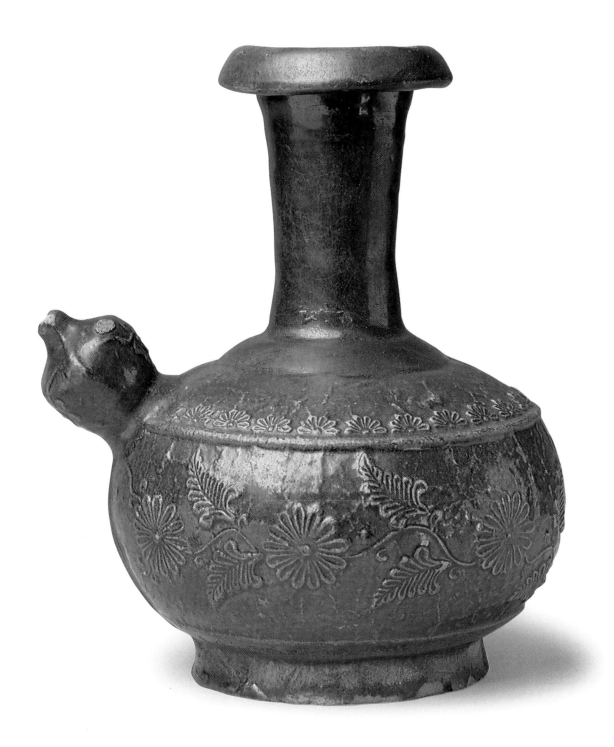

87

Gombroon bowl

Persia

Late 17th or early 18th century AD

H 7cm D 18.5cm

Bowl, 'Gombroon' ware. Composite white frit paste, coated with a transparent and colourless glaze with a greenish tinge. Rounded sides, slightly everted lip, on a low foot-ring, concave base with internal central convex boss inside. The vessel is decorated with openwork and underglaze-painted blue and black designs. The openwork consists of a series of vertical zigzag lines round the sides which are filled by the glaze. There is a simple cobalt blue painted geometrical design around the central boss at the base and the lip is decorated with black painted dashes and dots.

Comparative material

Fehérvári 1973, no. 183, plate 78a; Fehérvári and Safadi 1981, nos. 129-130.

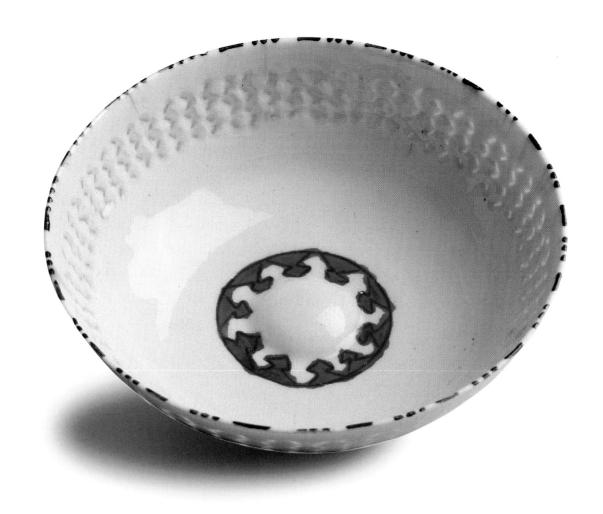

88

Gombroon bowl

Persia

Late 17th - early 18th century AD

H 4.3cm D 12cm

Small bowl, 'Gombroon' ware. Composite white frit paste covered with a transparent and colourless glaze with a greenish tinge, rounded sides, slightly everted lip, on a low foot-ring, with a convex boss inside and outside. The openwork decoration consists of dots and zigzag lines round the sides with the openings filled by the glaze. Across the boss at the base is a black painted floral spray.

Comparative material
SPA, 1938-9, pl. 811/A; Fehérvári and Safadi 1981, no. 131; Ishiguro, 1986, pl. 90.

89

Iznik polychrome plate

Turkey, Iznik
Last quarter of 16th century AD
H 5.5cm D 31.3cm

Plate, 'Iznik polychrome' ware. Composite white frit paste with cobalt blue, red, green and black painted decoration under a transparent and colourless glaze. Rounded sides, everted sloping rim, on a low foot-ring. The decoration consists of roses, carnations, tulips and hyacinths emerging from foliage. The rim is decorated with rock and wave patterns in blue and black. The outside is decorated with small flowers. Floral decorated vessels of this kind are attributed to the reign of Sultan Murad III (AD 1574-95/AH 982-1003).

Comparative material
Fehérvári, 1973, no. 215, p. 158, pl. 94a. Cf Atasoy and Raby, 1989, pp. 246 and ff.

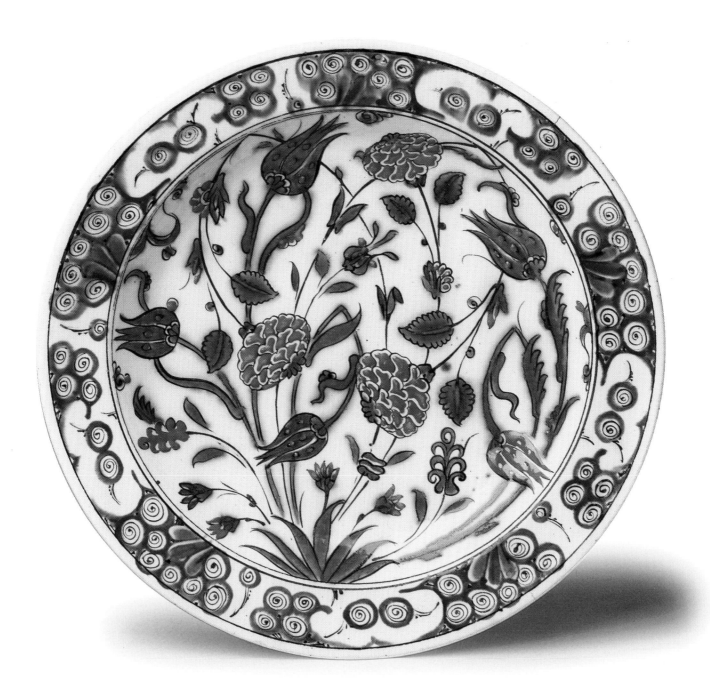

ISLAMIC METALWORK

With a single exception which comes from beyond the Oxus, the Islamic metalwork represented here is from Persia and dates from the 10th to the 14th centuries. Objects of household use, they are nevertheless objects of art by the nature of their form and decoration as well as technical finish. The exception is the important bronze ewer (object no. 91) with the pouring mouth in the form of a bull. A companion ewer was found by Russian archaeologists in the excavations at the site of Piyanjikent forty miles east of Samarqand. Piyanjikent was situated in the region known as Sogdiana centred on the valley of the river Zarafshan. It had been occupied in the 6th century AD by a Turkish people but at the beginning of the 8th century was conquered by Arab armies. Along with the ewer, pottery vessels also with mouths in the form of a bull have been found, so that possibly this kind of vessel may have had a particular significance we no longer understand. As the region was only recently settled by the Arabs we can hardly regard the ewer as Islamic. The inhabitants of Sogdiana, however, were to prove their ability in the Islamic period by a distinctive type of metalwork, both in silver and base metals, in the 9th and 10th centuries. Vessels in the form of animals and birds have a very ancient history in the Near East and Persia as well as in Central Asia. In Persia the vessel in the form of a bull from Marlik Tepe has already been described and we shall have occasion to describe a Persian incense burner in the form of a bird.

Of the remaining nine objects presented here, eight come from eastern Persia, a region known by the mediaeval period as Khurasan, and date from the 9th to the early 13th centuries. Many examples of the metalwork of this region have come to light. A great number of the forms are those of the ancient world, but others are wholly new creations. The vase (object no. 93) is a type which seems to have been developed in Khurasan though it subsequently found its way to western Persia where it was adopted as a pottery form. Another type of vessel was the hooded incense burner, again of Khurasanian origin, while the other incense burner in the form of a bird is an example of animal forms adapted to everyday use and widely current in the Islamic period, both in Persia, Muslim Spain and Egypt.

There are two types of ewer. First, the ewer with cylindrical body, flat shoulder and combined pouring and filling spout, the filling element projecting upwards (object no. 96). The most splendid were given round or angular flutes on the body and inlaid with silver. Related to this type is the ewer with a more or less spherical body and a combined pouring and filling spout similar to that of the other ewer (object no. 95); and it is possible that this is the earlier of the two forms.

Although the form of lampstand, with shaft supported on tripod legs and surmounted by a circular tray, originated in the Mediterranean region before Islam, it underwent a

number of alterations in the Islamic world. There are, however, certain constant factors: the tripod base and the shaft with at least two balusters. In Khurasan, the base was given a semi-dome and its horizontal edge was cut out at intervals with animal or bird heads. Such is the treatment of the base of the Hadji Baba lampstand (object no. 97) which has a long shaft,
hexagonal in section with a baluster at each end. There are two types of pen-case in the Islamic world; the one wedge-shaped and designed to be tucked into the belt and the other rectangular with a hinged lid and divided into two compartments for ink and pens respectively. In Persia both forms are found but the preferred form is rectangular with rounded ends as in object no. 99.

A striking feature of Islamic metalwork is the attention to decoration; a piece entirely without decoration is rare. The principal form of decoration in early Islamic metalwork is engraving; panels and friezes of vegetal or geometric ornament are applied always discretely in order to accentuate the form. A particular feature of Islamic metalwork, as of much of the art of Islam, is the use of calligraphy. In many of the pieces described here there are bands of calligraphy which carry equal status as decoration. The content of such inscriptions, which in the earlier objects are invariably in Arabic, is generally benedictory, that is, prayers for the well-being of the owner. The beauty of the Arabic script lent itself to decoration and much use was

made of the various forms of Arabic writing. Thus the angular kufic script provided a contrast to the rounded and flowing *thuluth* (object nos. 96 and 98). Inscriptions in the Persian language are found on later pieces such as the bowl (object no. 100) from western Persia inscribed with verses in it's praise.

Besides engraving, openwork could be used to great effect, as on the splendid lampstand (object no. 97) where the long shaft, balusters and the semi-dome of the base are greatly enhanced by their rendering
in floral and geometric designs. On the incense burners (object nos. 92, 94) the openwork was required by their nature and function.

Sometimes the metalwork of Khurasan was inlaid with copper to provide a contrast with the brass or bronze. On the bronze ewer (object no. 95), the name of the maker is inscribed in *kufic* inlaid with copper. Finally, on the more costly, and therefore rare pieces, from the 12th century onwards, decoration was inlaid with silver (object nos. 98, 99, 100); but the silver is used sparingly as a foil to the engraved elements. Thus on the bucket (object no. 98) only the letters of the inscribed bands are inlaid in silver, the scrolling ground being engraved. The decoration of the pen-box (object no. 99) is entirely in silver inlay, but the *kufic* letters and the two beautiful roundels are extremely fine, so that there is no sense of a surfeit of ornament.

90

Bronze ewer

Transoxiana (Soghdia)

Early 8th century AD

H 28cm

Bronze ewer in the form of a bull. Pear-shaped body with pouring spout projecting from the lower front in the form of the neck and head of a bull. A slight angular break around the lower part of the neck may be intended as a collar since there is a small round stud to the front. The three legs, each terminating in a hoof, are arranged to form a tripod. The filling spout, which forms a hump, is provided with a conical hinged lid with a thumb-piece in the form of a round leaf. The curved handle is attached to the back of the rim of the filling spout and to the lower part of the body. A bronze ewer closely related to this ewer has been recovered in the Soviet excavations at the city of Piyanjikent. This ruined site, some forty miles east of Samarqand, was the capital city of Sughd, or Sogdiana, a region comprising the valley of the river Zarafshan. From the 5th century to its conquest by the Arabs in the early 8th century, it was the centre of a kingdom with a distinctive culture in which Zoroastrianism seems to have been the dominant religion. The bronze ewer has been dated on archaeological evidence to the early 8th century when the Arabs were establishing themselves in the valley.

91

Bronze incense burner

Persia

10th - 11th century AD

H 20.5cm

Bronze incense burner, cast, with engraved and openwork decoration. Cylindrical body supported on three feet, hood on rear half of body in the form of a semi-dome. Surmounting the latter is a perching bird with folded wings. The surface of the hood is divided into two gussets at the rear, each decorated with openwork scrolls. On the forepart of the semi-dome descending from either side of the bird is a vertical band decorated with a series of openwork diamonds, partly engraved, within a square. Attached to the edge of the opening of the hood, suggesting the tympanum of an arched niche is a bronze plate carved and engraved with confronted quadrupeds, possibly hounds. On the cylindrical body are three vertical panels engraved with foliate scrolls immediately above each foot and three rectangular panels each divided into four triangular compartments by a raised X, each compartment decorated with an engraved knot or an engraved foliate scroll.

This type of incense burner seems to have originated and developed in Khurasan where it was current up to the middle of the 13th century.

Comparative material
Baer 1983, pp. 50-53 and figs. 36-39; Fehérvári and Safadi 1981, p. 102f, nos.44,45; SPA 1938-9, 1299A-D; Fehérvári 1976a, nos.93, 94, pl. 31; Melikan-Chirvani 1982, no.3, p.43 and fig 8, p.33

92

Bronze vase

Persia, Khurasan

12th century AD

H 24cm

Cast bronze vase of baluster form with broad flaring mouth, a raised collar around the neck, the broad splayed base cast separately. The mouth is decorated in openwork with a repeat pattern of paired semicircles and circles above a quincunx. The collar around the neck bears a relief inscription in floriated *kufic* much worn and barely decipherable but apparently containing good wishes to the owner. The convex surface of the foot is decorated with what appears to be floral or foliate scrolls on an openwork ground. This type of vase seems to be confined to Khurasan. The shape occurs in lustre-painted pottery (Grube 1976, no. 159, p. 219), but the bronze versions seem to be confined to Khurasan. They have been described variously as vases, oil lamps and incense burners.The example formerly in the Prince Sadruddin Aga Khan Collection (Sotheby's, 16 April 1986, lot 72) is decorated in openwork on the body and could therefore be either an oil lamp or an incense burner. Ours follows the exact form of another example which lacks, however, the openwork decoration and has also been described as a lamp (Sotheby's, 11 October 1989, lot 90). The same type of vessel is depicted in the engraved decoration on the ewer number 96.

Comparative material

For examples other than those already mentioned, see Sotheby's, 19 October 1983, lot 34; Louisiana 1987, no. 42, an early example, in the David collection, Copenhagen, with flaring mouth but no splayed foot, deep ribbing on mouth and body; Montgomery-Wyaux 1978, no. 5, is a crude version of this; Fehérvári 1976a, no. 57, pl. 17c and p. 64f.

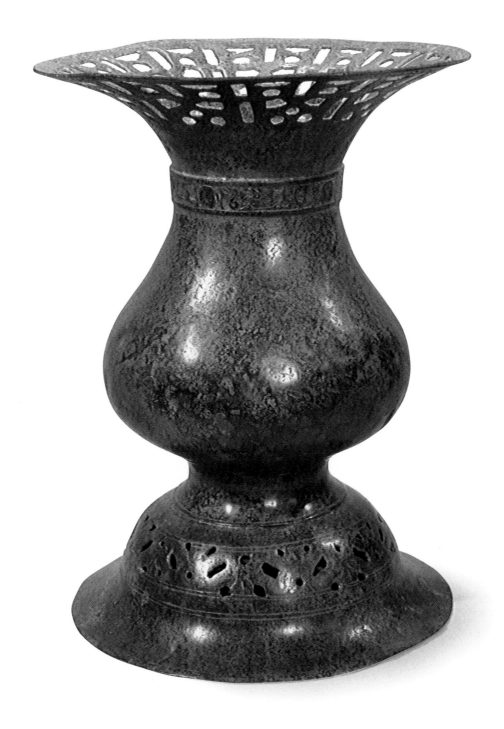

93

Bronze incense burner

Persia, Khurasan

12th century AD

H 23cm W 8.4cm L 16cm

Bronze incense burner in the form of a bird. Cast, engraved and pierced. The bird is standing with folded wings. Engraved on its breast are five-petal flowers within ogival compartments arranged in rows and on each wing four flowers of five petals with heads pointing inwards to form a roundel. Engraved on the outside of the thigh, a vase with flowers(?). Piercing on breast, wings and tail to release the incense. This incense burner is now in the Ishiguro Collection and it has not been possible to study its construction, more particularly the method of inserting the incense. The bird would seem to be a partridge although the beak is more like that of a raptor. The 'ears' are an anachronism and possibly may be explained as some confusion with a griffin where the head in type form of a bird predator is given ears.

Private collection

Comparative material
The bird form was adopted by the Islamic metalworkers for use as aquamaniles as incense burners or as free-standing objects. The best known aquamanile of this type is in the Hermitage Museum (Hermitage 1990, no. 1). This is of bronze, cast, engraved and inlaid in copper and silver. It is inscribed with the maker's name, the date 180 (796-7 AD) and the town where it was made, but of this there is no agreed reading. The form was popular in Khurasan up to the 12th century (Baer 1983, p. 59, fig. 42; Gladiss and Kröger 1984, pl. 26, no. 234; Folsach 1990, p. 189, fig. 309).

94

Bronze ewer

Persia, Khurasan
11th - 12th century AD
H 31cm

Hammered bronze ewer. Pouring spout projects upwards from cylindrical neck which serves as filling spout, both with thickened rim; a raised collar just above base of latter. Flat shoulder sloping slightly downwards to a rounded edge from which the side of the cylindrical body descends to a flat base. Handle in the form of a crosier, square to roundish in section, attached to the rear upper edge of filling spout and the upper part of the body. On shoulder, an engraved band of *thuluth* on a scrolling ground and on front of body, a human-headed sphinx facing left and flanked by a vase with flaring neck on baluster body and splayed foot which is decorated with scrolls; from the vases issue flowers; above, an arch formed of a band of *kufic*. On back below base of handle is engraved a crescent moon with foliate scrolls. Engraved guilloche just above base and on sides of handle; indeterminate engraved decoration on rounded upper edge of body. Inscription in Arabic on shoulder reads, starting from handle:

[two words indecipherable]

'. . . might and good fortune and prosperity and spiritual integrity and felicity. . . and completion and tranquility'

Inscription on front of body:
'Bliss and grace and sovereignty'

Comparative material
There is a ewer in the Los Angeles County Museum of identical form and with almost identical decoration (Pal 1973, no. 304). This is a simplified version of the fluted or gadrooned cylindrical body on a splayed foot and decorated with silver inlay (Scerrato 1966, pl. 24). The motif of flowers issuing from a vase can be seen on a bucket and a ewer (SPA 1938-9, pl. 1292A, 1309C).

95

Bronze signed ewer

Persia, Khurasan

12th century AD

H 32cm

Bronze ewer. Upturned pouring spout on slightly funnel-shaped neck, globular body on low foot. Crosier-shaped handle with thumb-piece in form of a pomegranate (?) attached to rear of rim and to lower part of body. Relief bands where the neck joins the pouring spout and another around the lower part of the neck. On the lower part of the pouring spout an engraved band of foliate scrolls terminating at both ends in a bird's head. Ring attachments on either side of neck and another on underside of pouring spout; there is also an 'eye hole' on the outside lower end of the handle. The neck and pouring spout are decorated with engraved bands of foliate scrolls. On the shoulder and around the base of neck, a band with 'chain' motif in low relief. On the curve of shoulder on the front side of ewer is a raised band with *kufic* inscription inlaid with copper which reads: *'amal-i 'Uthman* ('made by Uthman'). This is flanked by two rosettes engraved and inlaid with copper.

On main face of body, engraved in Arabic in *kufic* script (to left from handle):

'Bliss and grace and peace and lasting life'

Comparative material

Ewers of this form were probably made in Khurasan. The few which are decorated with silver inlay are of the 12th century; most, however, are decorated with copper inlay only and some may be as early as the 10th century. The group has some of the features, such as the distinctive pouring spout and crosier handle, of another group of ewers also attributed to Khurasan of which the bronze ewer, 96, is an example. Among the makers' signatures of this group is that of a metalworker from Ghazni (Baer 1983, p. 99). It has been suggested that the rings were intended for the attachment of lids. For other examples see al-'Ush 1972; Baer 1983, figs. 72-73; Louisiana 1987, fig.40.

96

Lampstand

Persia, Khurasan

12th - 13th century AD

H 71cm D(tray) 23.5cm

Bronze lampstand with openwork and carved decoration. The stand is supported on a tripod base, the column consists of three parts: a stem hexagonal in section between balusters surmounted by a circular tray attached to the upper baluster by bayonet fitting. The tray is flat and edged with vertical scallops. The knops of the upper and lower balusters have identical openwork decoration arranged in three registers: (a) a band of trefoils alternating with paired circles; (b) a guilloche of three strands; (c) band (a) reversed. The top and bottom of the main shaft are engraved with an identical band of *kufic* which on each face repeats the word *al-mulk*, 'sovereignty [belongs to God]'. Openwork decoration on each alternate face of the main shaft: (d) vertical composition of strands interwoven to form smaller within larger circles; (e) another vertical composition of full palmettes within ogival compartments and split palmettes in the interspaces. The lower baluster of the main shaft is attached to the short cylindrical shaft on the top of the shallow dome of the base. The shallow dome is decorated in openwork with precisely the same three registers as the two baluster knops. The circular profile of the platform surrounding the dome is interrupted by flat projections. On either side of the 'knee' of each of the three legs is the profile of a bird's head with inner details engraved. In each of the three interspaces of the 'knee' decorations is the

profile of a projecting leaf thickened at the tip and engraved with a knot within a roundel. At the back of these are three engraved cartouches containing foliate scrolls. The legs resemble boots which are each set on an oval plaque which just overrides the boot.

Comparative material

The basic type of Islamic lampstand, i.e. a column of baluster form surmounted by a circular tray set on a tripod base, was introduced in the early centuries of Islam from the Mediterranean regions (see Baer 1983, pp.7-10. The particular features of the Hadji Baba lampstand seem to have been developed in Khurasan and Transoxiana probably as early as the 10th century. An example formerly in the T L Jacks Collection (SPA 1938-9, pl. 1283 offers close parallels, particularly in the details of the openwork decoration; cf. also the lampstand in the Victoria and Albert Museum (Melikian-Chirvani 1982, p.53f, no.17) in which, however, the base is simplified and lacks the openwork decorated dome. For openwork decoration (d) of the shaft, cf. the incense burner of lynx form in the Hermitage Museum (Heritag 1990, no. 18).

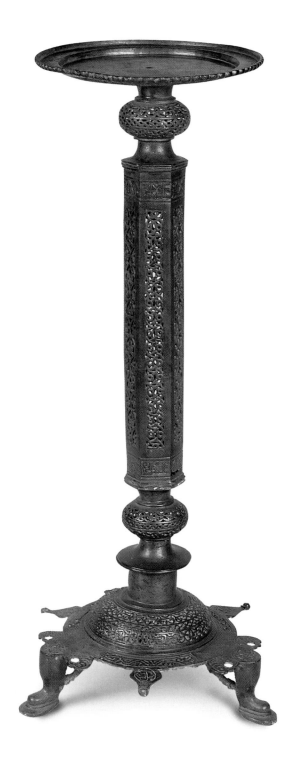

97

Silver-inlaid bronze bucket

Persia, Khurasan

12th - early 13th century AD

H(base to rim) 18.5cm D(rim) 18cm

Bronze bucket. Cast, engraved and inlaid with silver. Globular body with horizontal fiat rim and splayed foot. The looped ends of the semicircular handle are attached to vertical lugs on the rim of the vessel. Engraved decoration on rim consists of four small cartouches interrupted by the lugs and two groups of inscription bands. Decoration on the body is arranged in two main registers:

Upper: four cartouches containing *naskhi* inscriptions on a ground of tightly voluted scrolls alternating with four roundels each containing a peacock walking to left. The Arabic inscription is defective and can be read only in parts:

'and . . . and health and. . . /might and good fortune and. . . /. . . felicity and. . . /and peace and. . . and/'

Lower: four cartouches each containing three roundels in each of which is a peacock standing to left; the framing bands of the cartouches are interlaced with those of the roundels. These four cartouches alternate with four other cartouches each in the form of an arched niche with cusped outline, and containing paired birds with heads turned inwards and tail feathers crossing.

Below the lower register is a narrow band of plain *kufic*, much of it obliterated, interrupted by eight roundels each inlaid with a copper disc which in its turn is inlaid with silver chased with an intermediate

pattern. Gadroons are engraved on the curving underside of the vessel and the splayed foot is engraved with a row of paired vertical lines. Within the base itself are three engraved concentric lines. The silver inlay was probably added at a later date since inlays, apart from copper, are not characteristic of the group of buckets to which this belongs. In the inscribed bands the silver inlay does not always correspond to the engraved outlines on the bronze surface; and the chased silver inlays on the copper discs can hardly be an original intention. Moreover, the inlaying of the silver lacks the precision of the usual practice. The inlay, however, must have been applied at an early date - before the 15th century - since it is beneath the patination.

Comparative material.

This is one of a well-defined group of bronze buckets inlaid more often with copper than with silver and attributable to the workshops of Khurasan in the 12th and early 13th centuries. In the case of the Hadji Baba bucket, it is possible that the silver inlay has been added at a later date. The typical scheme of decoration, as here, comprises three main registers of decoration on the body: an upper register with a broad panel containing inscription in naskhi; a middle register of panels or cartouches containing figural or animal compositions and a lower containing a band inscribed in kufic (e.g. Scerrato 1966, fig. 21; Fehérvári 1976a, pl. 30, no. 91; Gladiss and Kröger 1984, pl. 243). For examples of the peacock on metalwork, see Baer 1983, p. 181, fig. 155, and a silver inlaid roundel on a 14th century money vessel from Fars in the Iran Bastan Museum, Tehran (Melikian-Chirvani 1982, fig. 87a, pl. 193).

98

Pen-box

Persia, Khurasan

Late 12th - 13th century AD

W 5.7cm H 2.7cm L 24.8cm

Bronze pen-box inlaid with silver. Rectangular with oval ends; the lid, with two hinges at the back, fits over the body which is provided with a rebate. On the bottom of the interior about one third from the right-hand end there are traces of a dividing wall; this would have provided a compartment for ink, the larger compartment being for the reeds. The face of the lid is decorated with silver inlay. At either end is a roundel containing a complex plaited pattern of a six-pointed star formed of two equilateral triangles - the so-called Star of Solomon - framed by sun rays. Between these roundels and along each long end is a line of *kufic* in thin bands of silver inlay. The Persian inscription is continuous and reads:

'With bliss and good fortune and good fortune and happiness and complete spiritual integrity [to] the owner [?]'

Private collection

Comparative material

The closest parallel is a bronze penbox, rectangular with rounded ends, in the L A Mayer Memorial Institute for Islamic Art (Baer 1983, p. 70, fig. 50). In this, however, the decoration on the lid is confined to an engraved roundel at either end containing a plaited pattern of the Star of Solomon combined with intersecting circles (Baer 1983, p. 130, fig. 107). The hinge clasps are more prominent and there are decorative clasps on the rounded ends of the lid. There is another pen-box of this type in the David Collection, Copenhagen (Folsach 1990, no 322) with copper and silver inlays. For a roundel with plaited pattern of a Star of Solomon framed by sun rays see Folsach 1990, no 321, where it forms the decoration in silver inlay of the lid of a cylindrical inkwell.

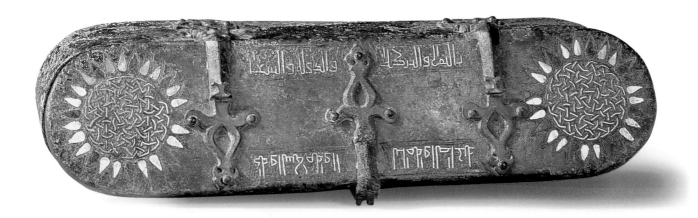

99

Silver-inlaid bronze bowl

Persia, Fars

Mid - 18th century AD

D 22.5cm D(opening) 16.5cm

Bronze bowl inlaid with silver. Flat inverted lip, low vertical rim, side of body curves outwards and downwards and then inwards to flat base. Decorative register on main field of body is framed by silver inlaid bands and consists of a silver inlaid cursive inscription on a scrolling foliate ground interrupted by eight small roundels each containing a swastika-like motif within larger cusped roundels on a ground of tightly voluted foliate scrolls. Below this main register are eight triangular cartouches at regular intervals with interiors of wicker work decoration. The inscription is in *naskhi* and consists of Persian verses in praise of the bowl (*tās*):

'This bowl which is a reservoir full of pure water,
Is for the purpose of purity of those endowed with perfection,
In the place of pleasure, thirsty, held in the palm of the hand,
It is a bowl brimful of water of eternity,
It is a bowl full of water, and turning it upside down (raising it to one's lips, and draining it), with a friend,
It is either the vault of heaven in which is the sun,

Or it is a casket for gems, or the house of Leo,
Or it is the cup which represents the whole world,
Or it is the mirror of a friend.'

On the rim:

Its owner, Zain al- 'Abidin, 1197 [1782-83 AD]

Comparative material
Western Iran became a centre of metalwork in the 14th century. There is good reason to think that a flourishing industry was established in the province of Fars. Three vessels bear the signatures of Shirazi craftsmen between 1305 and 1360 AD; Inscriptions on certain bowls connect them with Shiraz and one has a dedicatory inscription to the ruler of that city in the middle of the 14th century. The commonest arrangement of the decoration on the bowls consists of a broad band of thuluth between roundels containing figural subjects such as scenes of courtly life and the hunt. A bowl in the Museum für Islamische Kunst, Berlin (Gladiss and Kröger 1984, no 335) has the cusped roundels of the Hadji Baba bowl.

REFERENCES

Ades 1976: The Gurgan Finds. *A Loan Exhibition of Islamic Pottery of the Seljuq Period from the Raymond Ades Family Collection,* Bluett and Sons Ltd, London 1976

Albaum 1969: L I Albaum, 'O goncharnom proizvodstvne na Afrasiab v X-XI vv', *Afrasiab, Afrasiabskaya kompleksnaya archeologicheskaya ekspeditsiya,* Tashkent 1969

Atasoy and Raby 1989: Nurhan Atasoy and Julian Raby, *Isnik,* London 1989

Atil 1973: Esin Atil , *Ceramics from the World of Islam,* Washington 1973

Auth 1976: Susan H Auth, *Ancient Glass at the Newark Museum,* Newark 1976

Badre 1980: Leila Badre, *Les figurines anthropomorphes en terre cuite à l'Age du Bronze en Syrie,* Paris 1980

Baer 1983: Eva Baer, *Metalwork in Medieval Islamic Art,* New York 1983

Bahrami 1949: Mehdi Bahrami, *Gurgan Faiences,* Cairo 1949

Barag 1975: Dan Barag, 'Rod-formed Kohl-tubes of the Mid-First Millennium BC', *Journal of Glass Studies,* 17, 1975 pp 23-26

Barag 1985: Dan Barag et al., *Catalogue of Western Asiatic Glass in the British Museum,* London 1985
Bowen 1958: R L Bowen and F P A Albright, *Archaeological Discoveries in South Arabia,* Baltimore 1958

Caubert 1990: Annie Caubert, *Aux Sources du Monde Arabe: Collections du Musée du Louvre,* exhibition catalogue, Institut du Monde Arabe, Paris 1990

Charleston 1979: Robert J Charleston, *Masterpieces of Western and Near Eastern Ceramics, Islamic Pottery,* vol VI, Tokyo 1979

Clairmont 1977: Christopher L Clairmont, *Catalogue of Ancient and Islamic Glass,* Benaki Museum, Athens 1977

Constable-Maxwell 1979: *Catalogue of the Constable-Maxwell Collection of Ancient Glass,* sale catalogue, Sotheby Parke Bernet and Co., London, 4 and 5 June 1979

David Collection 1975: *Davids Samling Islamik Kunst: The David Collection of Islamic Art,* Copenhagen 1975

Dumarcay 1965: Dumarcay, 'Eolipiles?', *Syria,* XXXVI, 1965, pp 75-79

Ettinghausen 1939: Richard Ettinghausen, 'Parthian and Sassanian Pottery' in A U Pope (ed.), *A Survey of Persian Art from Prehistoric Times to the Present,* vol II, London and New York, 1939, reprinted Tokyo, 1967, pp 646-80

Ettinghausen 1965: Richard Ettinghausen, 'The use of sphero-conical in the Muslim East', *Journal of Near Eastern Studies,* vol XXIV, 1965, pp 218-29

Fehérvári 1973: Géza Fehérvári, *Islamic Pottery. A Comprehensive Study based on the Barlow Collection,* London 1973

Fehérvári 1976a: Géza Fehérvári, *Islamic Metalwork of the Eighth to the Fifteenth Century in the Keir Collection,* London 1976

Fehérvári 1976b: Géza Fehérvári, 'Safavid Pottery' in B W Robinson (ed.), *Persian and Mughal Art,* London, 1976, pp 261-300

Fehérvári and Safadi 1981: Géza Fehérvári and Yasin H Safadi, *1400 Years of Islamic Art,* Khalili Gallery, London 1981

Folsach 1990: Kjeld von Folsach, *Islamic Art: The David Collection,* Copenhagen 1990

Frankfort 1970: Henri Frankfort, *The Art and Architecture of the Ancient Orient,* revised impression, London 1970

Fukai 1968: Shinji Fukai, *Study of Iranian Art and Archaeology: Glassware and Metalwork,* Tokyo 1968

Fukai 1977: Shinji Fukai, *Persian Glass,* New York and Tokyo 1977

Fukai 1981: Shinji Fukai, *Ceramics of Ancient Persia,* Tokyo 1981

Fukai 1982-3: Shinji Fukai, *Ancient Persian Pottery,* Weatherhill, Japan 1982-3

Gladiss and Kröger, *Metall, Stein, Stuck, Holz, Elfenbein, Stoffe: Berlin Staatliche Museen Preussischer Kulturbesitz,* Museum für Islamische Kunst, Bd 2 Mainz 1984 Glass 1991: *Five Thousand Years of Glass,* British Museum, London 1991

Glass Studies: Journal of Glass Studies, Corning Museum of Glass, Corning, New York

Gluck 1977: J Gluck and S H Gluck (ed.), *Survey of Persian Handicrafts,* Tehran, New York, London and Ashiya 1977

Godard 1965: André Godard, *The Art of Iran*, London 1965

Goldstein 1979: Sidney M Goldstein, *Pre-Roman and Early Roman Glass in the Corning Museum of Glass*, Corning, New York 1979

Griefenhagen 1962: Adolf Griefenhagen, Ancient Glass in the Berlin-West Museum, *Journal of Glass Studies 4*, 1962, pp 61-66

Grose 1989: David Frederick Grose, *The Toledo Museum of Art: Early Ancient Glass, core-formed, rod-formed and cast vessels and objects from the late Bronze Age to the Early Roman Empire, 1600 BC to AD 50*, New York 1989

Grube 1976: Ernst J Grube, *Islamic Pottery of the Eighth to the Fifteenth Century in the Keir Collection*, London 1976

Habery 1966: Waldemar Habery, 'Zur Herstellung der römischen Wabenbecher', *Bonner Jahrbücher*, 166, 1966 pp 208-12

Hackin 1939: J Hackin, *Recherches archéologiques à Begram (Mémoires de la Délégation archéologique francaise En Afghanistan, 9)*, Paris 1939 Harden 1934: Donald B Harden, 'Snake-thread Glasses found in the East', *Journal of Roman Studies*, XXV, London 1935 pp 50-55

Harden 1987: Donald B Harden, *Glass of the Caesars*, Milan 1987

Harden 1968: Donald B Harden,' The Canosa Group of Hellenistic Glasses in the British Museum', *Journal of Glass Studies*, X, 1968 pp 21-47

Harden 1980: Donald B Harden, 'A Hellenistic Footed Glass Bowl of Alexandrian Workmanship', *The Toledo Museumof Art Museum News*, 22/2, 1980 pp 17-25

Harden 1981: Donald B Harden, *Catalogue of Greek and Roman Glass in the British Museum*, I, London 1981

Hennessy 1979: John Basil Hennessy, *Masterpieces of Western and Near Eastern Ceramics, I, Ancient Near East Pottery*, Tokyo 1979

Hermitage 1990: Masterpieces of Islamic Art in the Hermitage Museum: *Exhibition held in the Dār al-Athār al-Islāmiyyah*, Kuwait, 1990

Honey 1946: A B Honey, *Glass*, London 1946

Hrouda 1977: Berthel Hrouda, *Isin-Isan Bahriyat II, Die Ergebnisse der Ausgrabungen 1973-1974*, Munich, 1977

Hrouda 1981: Berthel Hrouda, *Isin-Isan Bahriyat II, Die Ergebnisse der Ausgrabungen 1975-1978*, Munich 1981

Ishiguro 1986: Kōjirō Ishiguro, *Ancient Art. Mr and Mrs K Ishiguro Collection, II, Islamic and Related Art*, Tokyo 1986

Isings 1957: Clasina Isings, *Roman Glass from Dated Finds*, Groningen 1957

Isings 1957: Clasina Isings, *Roman Glass from Dated Finds*, Groningen, Djakarta 1957

Isings 1971: Clasina Isings, *Roman Glass in Limburg*, Groningen 1971

Jenkins 1983: Marilyn Jenkins, *Islamic Art in the Kuwait National Museum*, London 1983

Kawani 1991: Trudy S Kawani, *Ancient Iranian Ceramics from the Arthur M Sackler Collections*, New York 1991

Kiani 1978: M Y Kiani, *Iranian Pottery*, Tehran 1978

Koechlin 1928: Raymond Koechlin, 'Les céramiques musulmanes de Suse au Musée du Louvre', *Mémoires de la Mission Archéologique de Perse*, XIX Paris 1928

Kofler-Truniger 1985: *Ancient Glass, formerly in the Kofler-Truniger Collection*, sale catalogue, Christie's, London, 5 and 6 March 1985

Lacam 1960: Jean Lacam, 'La céramique iranienne à l'exposition du Petit Palais à Paris', *Cahiers de la Céramique*, 19, 1960

Lamm 1928: C J Lamm, *Das Glas von Samarra: Die Ausgrabungen von Samarra*, Bd I, Mainz, reprint 1984

Lamm 1929-30: C J Lamm, *Mittelalterliche Gläser und Steinschnittarbeiten aus dem Nähen Osten*, Berlin 1929-30

Lamm 1935: C J Lamm, *Glass from Iran in the National Museum, Stockholm*, Stockholm and London 1935

Lane 1947: Arthur Lane, *Early Islamic Pottery*, London 1947

Lane 1957: Arthur Lane, *Later Islamic Pottery*, London 1957

Lawton 1987: Thomas Lawton and others, *Asian Art in the Arthur M. Sackler Gallery: The Inaugural Gift*, The Arthur M. Sackler Gallery, Washington D.C.,1987.

Louisiana 1987: *Art from the World of Islam: 8th -18th century, Louisiana Revy*, Vol. 27, no 3 [Humlebaek], March 1987

Lucerne 1981: *3000 Jahre Glaskunst von der Antike bis zum Jugendstil*, exhibition catalogue, Kunstmuseum Luzern, Lucerne 1981

Masterpieces 1968: Donald B Harden et al., *Masterpieces in Glass*, British Museum 1968

Matherson 1980: Susan B Matherson, *Ancient Glass in the Yale University Art Gallery*, New Haven 1980

Mayer 1959: L A Mayer, *Islamic Metalworkers And Their Works*, Geneva 1959

Melikian-Chirvani 1982: Assadullah Souren Melikian-Chirvani, *Islamic Metalwork from the Iranian World: 8th to 18th Centuries*, Victoria and Albert Museum catalogue, London 1982

Mikami 1962: Tsugio Mikami, *Islamic Pottery, mainly from Japanese Collections*, I, Tokyo 1962

Mikami 1964: Tsugio Mikami, *Islamic Pottery, mainly from Japanese Collections*, II, Tokyo 1964

Mikami 1966: Tsugio Mikami, *Perushka tōki no bi* (Studies on Persian Porcelain), IV, Tokyo 1966

Montgomery-Wyaux 1978: Cornelia Montgomery-Wyaux, *Métaux islamiques*, Musées Royaux d'Art et d'Histoire, Brussels 1978

Moorey 1987: P R S Moorey, *The Ancient Near East*, Oxford 1987

Muscarella 1974: Oscar White Muscarella, *Ancient Art: The Norbert Schimmel Collection*, Mainz 1974

Muscarella 1989: Oscar White Muscarella (ed.), *Ladders to Heaven: Our Judeo-Christian Heritage 5000 BC-AD 500*, exhibition catalogue, Royal Ontario 1989

Negahban 1977: Ezat O Negahban, *A Preliminary Report on Marlik Excavation Gohar Rud Expedition Rudbar 1961-1962*, Tehran 1977

Oliver 1967: Andrew Oliver, 'Late Hellenistic glass in the Metropolitan Museum', *Journal of Glass Studies*, x, 1968, pp 21-47 Oliver 1967: Andrew Oliver, 'Late Hellenistic glass in the Metropolitan Museum', *Journal of Glass Studies*, x, 1968, pp.21-47

Oliver 1970: Andrew Oliver, 'Persian Export Glass', *Journal of Glass Studies*, XII, Corning, New York, 1970, pp 9-16

Oliver 1980: Andrew Oliver, *Ancient Glass in the Carnegie Museum of Natural History, Pittsburgh*, Pittsburgh, 1980

Pal 1973: Pratapaditya Pal, *Islamic Art: The Nasli M Heeramaneck Collection*, Los Angeles County Museum of Art, Los Angeles, 1973

Platz-Horster 1976: G. Platz-Horster, *Antike Gläser*, Berlin 1976

Raspopova 1980: V I Raspopova, 'Metalicheskie izdeliia rannesrednivekovovo sogda' in A M Vilentsky (ed.), *Nauka Leningradskoe Otdelenie*, Leningrad, 1980

Rogers 1970: J M Rogers, ' Aeolopiles Again' in Oktay Aslanapa (ed.), *Forschungen zur Kunst Asiens in Memoriam Kurt Erdmann*, Istanbul, 1970, pp 147-58

Rosen-Ayalon 1974: Myriam Rosen-Ayalon, *La poterie islamique*, Mémoires de la Délégation Archéologique en Iran, L, Mission susiane, Paris 1974

SPA 1938-1939: A U Pope (ed.), *A Survey of Persian Art from Prehistoric Times to the Present*, VI vols., London and New York, 1938-1939 (reprinted Tokyo, 1967)

Saldern 1974: Axel von Saldern, 'Two Achaemenid Glass Bowls and a Hoard of Hellenistic Glass Vessels', *Journal of Glass Studies*, XVII, Corning, New York, 1975, pp. 37-46

Saldern 1980: Axel von Saldern, *Glass 500 BC to AD 900. The Hans Cohn Collection, Los Angeles California*, Mainz on Rhine, 1980

Saldern 1981: Axel von Saldern, *Glass 500 BC to AD 1900: The Hans Cohn Collection, Los Angeles, California*, Los Angeles,1981

Scerrato 1966: Umberto Scerrato, *Metalli islamici*, Milan 1966

Seyrig 1959: Henry Seyrig, 'Flacons? Grenades? Eolipiles?', *Syria*, XXXVI, 1959, pp. 81-9

Soustiel 1985: J Soustiel, *La céramique islamique*, Paris 1985

Starr 1939: R Starr, *Nuzi*, 2 vols., Cambridge, 1939

Tait 1991: Hugh Tait (ed.), *Five Thousand Years of Glass*, London, 1991

al-'Ush 1972: M Abu-I-Faraj al-'Ush, 'A bronze ewer with a high spout in the Metropolitan Museum of Art and analogous pieces' in *Islamic Art in the Metropolitan Museum of Art*, New York, 1972, pp. 187-98

Watson 1985: Oliver Watson, *Persian Lustre Ware*, London, 1985

Whitehouse 1968: David Whitehouse, 'Excavations at Siraf: Fifth Interim Report', *Iran*, X, London, 1972, pp. 63-87

Winfield Smith 1957: R W Winfield Smith, *Glass from the Ancient World, the Ray Winfield Smith Collection*, Corning,New York 1957

Wilkinson 1963: C K Wilkinson, *Iranian Ceramics*, New York, 1963

Wilkinson 1972: C K Wilkinson, *Nishapur: Pottery of the Early Islamic Period*, New York, 1972

INDEX